Artists of
the Renaissance

By James Barter

Lucent Books
P.O. Box 289011, San Diego, CA 92198-9011

Other Books in the History Makers Series:

Civil War Generals of the Confederacy

Civil War Generals of the Union

Fighters Against American Slavery

Leaders of Ancient Greece

Native American Chiefs and Warriors

Rulers of Ancient Egypt

Rulers of Ancient Rome

Scientists of Ancient Greece

Women Leaders of Nations

Women of the American Revolution

Library of Congress Cataloging-in-Publication Data

Barter, James, 1946–
 Artists of the Renaissance / by James Barter.
 p. cm. — (History makers)
 Summary: Discusses the life and work of six artists of the Italian
Renaissance whose works represent important innovations and
achievements in painting, sculpture, and architecture. Included are
Giotto, Donatello, Brunelleschi, da Vinci, Michelangelo, and Raphael.
 Includes bibliographic references and index.
 ISBN 1-56006-439-0 (lib. bdg. : alk. paper)
 1. Art, Italian—Juvenile literature. 2. Art, Renaissance—Italy—
Juvenile literature. [1. Art, Italian. 2. Art, Renaissance—Italy.
3. Artists.] I. Title. II. Series.
N6915.B284 1999
709'.45'09024—dc21 98-29497
 CIP
 AC

1 P.95

CONTENTS

FOREWORD

The literary form most often referred to as "multiple biography" was perfected in the first century A.D. by Plutarch, a perceptive and talented moralist and historian who hailed from the small town of Chaeronea in central Greece. His most famous work, *Parallel Lives*, consists of a long series of biographies of noteworthy ancient Greek and Roman statesmen and military leaders. Frequently, Plutarch compares a famous Greek to a famous Roman, pointing out similarities in personality and achievements. These expertly constructed and very readable tracts provided later historians and others, including playwrights like Shakespeare, with priceless information about prominent ancient personages and also inspired new generations of writers to tackle the multiple biography genre.

The Lucent History Makers series proudly carries on the venerable tradition handed down from Plutarch. Each volume in the series consists of a set of six to eight biographies of important and influential historical figures who were linked together by a common factor. In *Rulers of Ancient Rome*, for example, all the figures were generals, consuls, or emperors of either the Roman Republic or Empire; while the subjects of *Fighters Against American Slavery*, though they lived in different places and times, all shared the same goal, namely the eradication of human servitude. Mindful that politicians and military leaders are not (and never have been) the only people who shape the course of history, the editors of the series have also included representatives from a wide range of endeavors, including scientists, artists, writers, philosophers, religious leaders, and sports figures.

Each book is intended to give a range of figures—some well known, others less known; some who made a great impact on history, others who made only a small impact. For instance, by making Columbus's initial voyage possible, Spain's Queen Isabella I, featured in *Women Leaders of Nations*, helped to open up the New World to exploration and exploitation by the European powers. Unarguably, therefore, she made a major contribution to a series of events that had momentous consequences for the entire world. By contrast, Catherine II, the eighteenth-century Russian queen, and Golda Meir, the modern Israeli prime minister, did not play roles of global impact; however, their policies and actions significantly influenced the historical development of both their own

countries and their regional neighbors. Regardless of their relative importance in the greater historical scheme, all of the figures chronicled in the History Makers series made contributions to posterity; and their public achievements, as well as what is known about their private lives, are presented and evaluated in light of the most recent scholarship.

In addition, each volume in the series is documented and substantiated by a wide array of primary and secondary source quotations. The primary source quotes enliven the text by presenting eyewitness views of the times and culture in which each history maker lived; while the secondary source quotes, taken from the works of respected modern scholars, offer expert elaboration and/or critical commentary. Each quote is footnoted, demonstrating to the reader exactly where biographers find their information. The footnotes also provide the reader with the means of conducting additional research. Finally, to further guide and illuminate readers, each volume in the series features photographs, a chronology, two bibliographies, and a comprehensive index.

The History Makers series provides both students engaged in research and more casual readers with informative, enlightening, and entertaining overviews of individuals from a variety of circumstances, professions, and backgrounds. No doubt all of them, whether loved or hated, benevolent or cruel, constructive or destructive, will remain endlessly fascinating to each new generation seeking to identify the forces that shaped their world.

A Second Brief Moment

Only twice in the more than thirty-five-hundred-year history of Western civilization has humankind set aside the scourges of war, social conflict, and other forms of discord to hold on high, for a brief, radiant moment, the intellectual achievement of a time and place. The first brief moment, dubbed the golden age of Greece, lasted a mere fifty years during the fifth century B.C. During this period the city-state of Athens was home to many of the world's greatest philosophers, mathematicians, poets, playwrights, sculptors, and historians. The second moment, two thousand years later, lasted about three hundred years. During this time Italy, led by the city of Florence, experienced a great intellectual burst. Dubbed the Renaissance, this second glorious golden age of intellectual achievement has not been equaled since.

The golden age of Greece saw the emergence of philosophers, poets, playwrights, artists, and sculptors. This period marked a pinnacle of cultural achievement in the Western world.

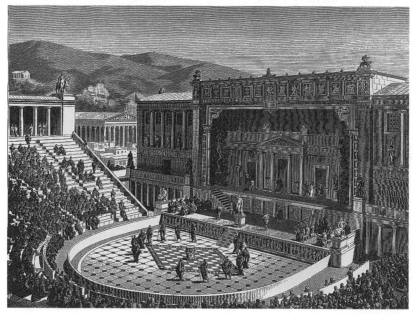

No period of history within the sweep of Western civilization can lay greater claim to a more energetic flurry of art or a more resplendent artistic period than can the Renaissance. During the fourteenth through the sixteenth centuries, northern Italy, followed by other European countries, witnessed the greatest proliferation of artists, art, and cultural enrichment the Western world has ever experienced.

The Crossroads

Born at the crossroads of many revolutionary historical events, the Renaissance exploded into existence in Italy with sufficient force to shatter the eight hundred years of relative cultural and intellectual stagnation that historians call the Middle Ages. Unprecedented, energetic, and avant-garde, Renaissance thinkers exchanged intellectual ideas celebrating the supremacy of humankind and washed away the cultural and spiritual anguish of the Middle Ages.

The events converging at this crossroads gave life to the largest number of artistic geniuses of any period of Western civilization. Membership within this pantheon of Renaissance giants includes the likes of Leonardo da Vinci, Michelangelo, Giotto, Donatello, Raphael, Brunelleschi, Cimabue, Ghiberti, Masaccio, Verrocchio, Bramante, Fra Angelico, Giorgione, Titian, and countless other lesser-known yet significant artists whose masterpieces hang beside

Leonardo da Vinci's innovative work is considered priceless. His technique and use of color express the prevalent thoughts and feelings of his time.

those of the giants. These artists, revered throughout the art world, created masterpieces whose values are described not in thousands or even in millions of dollars, but rather in the elegant simplicity of "priceless."

These blue bloods of the Renaissance bloodied their knuckles hammering jagged blocks of marble until statues of international fame emerged known to the world as *David, Moses,* and the *Pietà.* They pulverized and then blended insects, flowers, and minerals to create the palette of colors used to adorn entire walls with spiritual visions called the *Last Supper,* the *Last Judgment,* and the *School of Athens.* They also learned the math and engineering principles required to build the great cathedrals of Europe; every

year millions of tourists are filled with solemnity and awe when visiting St. Peter's in Rome, Santa Maria del Fiore in Florence, and the Leaning Tower of Pisa.

These princely works, along with hundreds of lesser-known masterpieces, are the gifts of the Renaissance. Forged from the muscles and souls of the artists who lived, worked, and died perfecting their craft and sullen art, they silently abide in museums and cathedrals. There, the masterpieces await the flashing eyes of wondrous faces that look in amazed disbelief and wonder about the lives of the artists who lived at that crossroads hundreds of years ago and thousands of miles away.

Six Titans

The six Renaissance artists featured in this book have been chosen because they portray a fair representation and progression of art during the early Renaissance and the late Renaissance, commonly referred to as the High Renaissance. Representing art during the early Renaissance are Giotto, a painter; Donatello, a sculptor; and Brunelleschi, an architect. Representing the High Renaissance are the universally recognized triad of Leonardo da Vinci, Michelangelo, and Raphael. Each of these artists was selected for his innovative ideas and techniques that furthered the development of art as well as for his ability to express the prevalent thoughts and feelings of his times.

Each artist in this book broke from his predecessors, making an innovative contribution to the development and evolution of art. The three representing the early Renaissance, Giotto, Donatello, and Brunelleschi, lived during a period of radical departure from the dominant traditions of the Middle Ages. Each grappled to define, in his respective medium, a new vitality not seen during the Middle Ages. To overcome the momentum of the Middle Ages, each struggled to express and then perfect the principles of humanism and classicism.

The three masters representing the High Renaissance, Leonardo da Vinci, Michelangelo, and Raphael, are known for the advances they made over their predecessors of the early Renaissance, on whose shoulders they stood to achieve their modern stature and fame. They achieved an exceptionally high degree of perfection and realism, implementing the principles of humanism and classicism.

Much of our knowledge regarding the lives of these men comes to us from the sixteenth-century biographer of Renaissance artists Giorgio Vasari. Vasari is the most important historical source for learning about the artists of the Renaissance even though he lived

much later than most of them. Although his biographies are often sparse for many of the earliest artists and he sometimes exaggerates their achievements, Vasari nonetheless provides useful information about each artist.

Humanism

The humanist movement that emerged during the Renaissance expressed the belief that human beings have a basic value and dignity worthy of celebration. This doctrine, in direct conflict with that of the Catholic Church during the Middle Ages, placed primary importance on life on the earth rather than on life after death as taught by the Church. The humanist movement valued relationships between people; the Church, in contrast, valued relationships between people and God.

Embracing the ideal that people are of central importance, Renaissance artists gradually shifted their focus from depicting principally dark, somber, and dispassionate biblical themes to depicting people expressing emotions toward one another. As a result, depictions of the human face and body achieved greater realism as they became softer and more expressive.

The focus on greater realism became evident in the rendering of people and scenes of nature. Artists experimented with paints and learned to apply them to realistically represent the subtleties of light and darkness. Realism was also achieved by the careful study of anatomy, which translated into realistic renderings of the wrinkled faces and gnarled hands of the elderly and the muscles and veins of an athletic body.

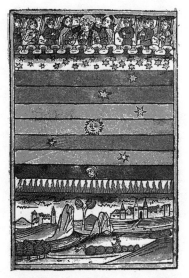

A medieval illustration shows the supreme importance of God and heaven, set high above human existence on earth.

Many artists of the High Renaissance studied human anatomy by dissecting corpses. This practice helped them to better understand how muscle, bones, tendons, and blood vessels affect the appearance of the face and body.

Realism found another avenue of expression in perspective, the technique of accurately representing a three-dimensional object on

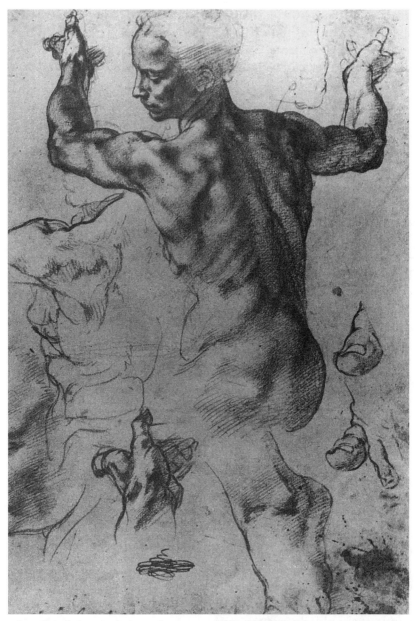

This sketch by Michelangelo represents a three-dimensional object on a two-dimensional surface. This figure later appeared in the Sistine Chapel.

a two-dimensional painted or sketched surface. Perspective is based on the optical principle that objects close to a viewer appear larger and more detailed than distant objects. The classic example of this is the illusion of a pair of railroad tracks receding into the distance. As they move away from the viewer, they gradually *ap-*

pear to move together although they remain parallel and the distance between the wooden ties remains the same. As obvious as this simple principle is to the modern spectator, artists of the Middle Ages did not understand perspective. Art from that period, lacking correct perspective, appears flat and poorly proportioned.

By embracing the humanist doctrines, the early Renaissance artists more realistically depicted the entire range of human emotion. People, even biblical figures, shed their flat, cold postures and blank stares of medieval art for relaxed poses and expressive faces characteristic of the Renaissance. The realistic expression of emotion reached its highest and most subtle climax during the High Renaissance.

Classicism

Classicism refers to the influence that Greek and Roman artists and thinkers exercised over Renaissance art. After visiting Athens and Rome to study the architecture and sculpture, Renaissance artists incorporated many of the classical themes, symbols, and techniques into their own works. As classical influences increasingly found their way into Renaissance art, the intelligentsia enjoyed connecting themselves to the classical masters whom they revered.

Regardless of when or where the six artists of this book lived, all paid homage to their Greek and Roman predecessors. This recognition manifested itself in architectural renderings of Greek marble columns used to frame many frescoes, in Greek statues used as decoration in paintings, in Roman arches painted to draw the viewers' attention to central figures, and Roman equestrian statues used as models for contemporary equestrian bronze statues.

Toward the end of the Renaissance, painters, sculptors, and architects executed works combining symbols and styles of classical Greece and Rome with those of the Renaissance. During the High Renaissance, Leonardo da Vinci, Michelangelo, and Raphael honored their Greek and Roman predecessors by not only copying many of their ancient works but also by representing them in painted and sculpted form.

The Rediscovery

The meaning of the term *Renaissance* derives from the Latin *renascor*, meaning "to be reborn" or "rediscovered." The term stems from the observation that the Renaissance represented a rediscovery of classical art and knowledge that had laid relatively dormant during the eight-hundred-year period of the Middle Ages. Books in private collections and in the basements of churches and monasteries were dusted off and read with new interest. This encyclopedic body of knowledge, handed down from the Greeks and Romans, contained revered wisdom on art, philosophy, literature, astronomy, engineering, geography, mathematics, medicine, and economics—the legacy of the golden age of Greece and the master builders of the Roman Empire.

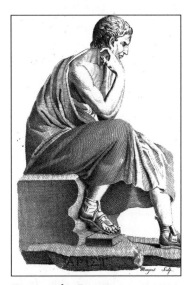

During the Renaissance, many people rediscovered the works of ancient Greek philosophers such as Aristotle.

When the Renaissance began to emerge from the cultural relapse of the Middle Ages around the fourteenth century, people started to read the classical authors on a large scale. From the Greeks, they rediscovered the wisdom of Plato, Aristotle, Sophocles, Homer, Sappho, Heraclitus, Euclid, Herodotus, and Thucydides. From the Romans, they studied the writings of Caesar, Cicero, Virgil, Catullus, Seneca, Pliny, and Tacitus. In addition to reading these peerless thinkers, they made visits to Athens and Rome to personally survey the great works of ancient sculptors and architects. For Renaissance artists, no compliment carried with it greater prestige than that of being favorably compared to the Greek and Roman masters. In his 1456 book *Illustrious Men,* author Bartholomeo Facio praises the Renaissance sculptor Donatello: "Donatello ex-

cels [in] his talent and no less [in] his technique; he is very well known for his bronze and marble figures, for he can make people's faces come to light, and in this he comes close to the glory of the ancient masters."[1]

The Sweep of the Renaissance

The Renaissance, today primarily associated with the luminaries of Italian art, was by no means limited to that one arena of intellectual exploration or that one European country. One of the extraordinary characteristics of the Renaissance was its scope, casting its net across Europe to encircle all fields of intellectual curiosity. Far from being limited to the arts, the spirit of the Renaissance also found powerful expression in explorations of science, mathematics, medicine, literature, philosophy, and the planet. Those rare individuals whose intellectual powers are great enough to encompass this broad sweep of topics have been honored for centuries with the privileged title, "Renaissance Man."

Explorers were propelled westward by the realities of inexpensive spices and exotic wares as well as by the fantasies of cities of gold and fountains of youth. These bold adventurers set out from Europe in small wooden ships to find a western passage to the East that would allow them to discover and exploit the New World. Not knowing if their efforts would be successful, they

Adventurers like Christopher Columbus fully embraced the Renaissance ideals of discovery and exploration.

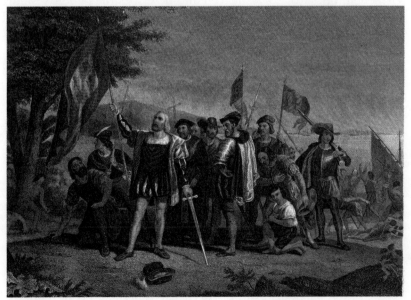

sailed through disease and deprivation hoping to find riches and fame for their homelands. Explorers like Christopher Columbus (1451–1506) explored the West Indies, Vasco Núñez de Balboa (1475–1519) sailed the Pacific Ocean, Hernán Cortés (1485–1547) conquered Mexico, Ferdinand Magellan (1480–1521) circumnavigated the world, and Sir Francis Drake (1540–1596) sailed along the coast of California, ironically missing the jewel of the West Coast, San Francisco Bay.

Explorers of a different ilk focused their energies on exploring the heavens in search of celestial understanding. The astronomer Nicolaus Copernicus (1473–1543) plotted the movements of the planets, discovering the Sun to be the center of the solar system. Galileo Galilei (1564–1642) made a telescope and discovered that Venus revolves around the Sun, that Jupiter has four moons, and that Saturn has rings. Johannes Kepler (1571–1630) formulated the laws of planetary motion and, in so doing, discovered that their orbital paths were elliptical, not circular, and that he could derive their distances from the Sun by the length of their revolutions. Sir Isaac Newton (1642–1727) observed that a force exists between planets that holds them in orbit; he mathematically described that force, which we know today as the law of gravity.

Explorers seeking to understand the human psyche wrote literary works still read and revered hundreds of years later. Dante Alighieri (1265–1321) wrote the *Divine Comedy* in which he fancifully visits hell, purgatory, and heaven and describes the people residing there. Niccolò Machiavelli (1469–1527) explored the qualities of successful political leaders in his book *The Prince*. Miguel de Cervantes (1547–1616) entertained readers in *Don Quixote* with stories of a man on a broken-down horse traveling with a disheveled sidekick who saved imaginary maidens from the evils of the world. In England a playwright and poet by the name of William Shakespeare (1564–1616) composed the most esteemed body of writings in any language, for any time.

Why these diverse explorations by these remarkably unorthodox thinkers occurred at this time and place is a matter of considerable debate among historians. As much as they may dispute the details of this question, they generally agree on the larger explanations for the origins of the Renaissance.

Origins of the Renaissance

The fourteenth century marks the beginning of one of the most fertile periods in European history—the Renaissance. In many re-

spects, the Renaissance could not have occurred had it not been for the regressive nature of the Middle Ages, which followed the collapse of the Roman Empire.

When the collapse occurred in the late fifth century, spurred along by repeated invasions of Rome by Germanic tribes, the safety, prosperity, and security that Europeans had enjoyed for hundreds of years under the protective umbrella of the Roman Empire vanished. Nothing replaced that umbrella, leaving Europe without a social or political structure to ensure continued prosperity and achievement. The unity and quality of life that Europe had enjoyed under the Roman Empire was now shattered.

Since life during the Middle Ages was relatively stagnant, some historians refer to the Middle Ages as the Dark Ages. Life unfolded relatively undisturbed by events beyond the European borders until 1071, when the Seljuk Turks, who were adherents to the Muslim religion, conquered an area known to Europeans as the Holy Land. Christians revered this land as the place Jesus lived, taught, and died, and they made frequent pilgrimages there to pay homage to his teachings. With this conquest, the Seljuk Turks ended the pilgrimages, cutting off Christians from their most sacred landmarks. When the pope in Rome received news of this affront, he proclaimed a holy war; historians refer to this war as the Crusades, and they would later trigger the Renaissance.

The Crusades and Trade

Intermittently waged for 175 years, the Crusades were a series of military expeditions undertaken by western European kings at the requests of popes between 1095 and 1270 to recapture militarily the Holy Land from the Muslims.

Initially the crusaders experienced success against the Muslims, but in time, what they had quickly won they later quickly lost. Armies that set out for the Holy Land under disciplined leaders quickly degraded into roving bands of marauders more intent on stealing and pillaging towns en route to the Holy Land than fighting the Muslim armies.

At the conclusion of the Crusades, the region most changed by the events of the wars was Europe, not the Holy Land. Christian crusaders lost the military war against the Muslims, but Christian traders won the lucrative commercial war. Crusading armies that initially set out to liberate the Holy Land from the Muslims returned home to sell at great profit the goods they had acquired in the Middle East. Ships carrying crusading soldiers to the war

returned home loaded with exotic commodities in quantities sufficiently great to propel their owners into the ranks of the new merchant class of millionaires.

Wealth and Education

As trade flourished in northern Italy's cities, shipbuilders, shipowners, and traders began amassing unprecedented fortunes. As these entrepreneurs acquired increasingly larger personal fortunes, they pioneered the lending of money at high interest rates, allowing them not only to make money at their professions but also on their surplus money. The banking and lending industries became so profitable in Florence that the city minted its own gold coin, called the florin, the standard currency for all of Europe for hundreds of years. Powerful banking and shipping families became famous for their massive fortunes.

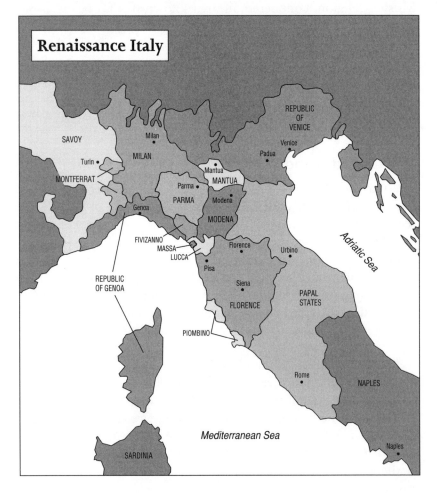

The rediscovery of the great Greek and Roman thinkers, artists, and writers prompted formal education for upper-class children and the development of Europe's first universities.

The emergence of wealthy families created generations of children who no longer faced the grim reality of tilling the soil behind a plow horse or working in cities at menial or dangerous jobs for substandard wages. For the first time in many generations, the children of wealthy parents had what the ancient Greeks called σχολαζω (pronounced scholaxo), meaning "leisure time." From this Greek word, the English language derives many words related to learning, including *scholar, scholastic,* and *school.*

Parents quickly filled their children's newly found leisure time with formal education. Learning began to flourish as Europe's first great universities emerged amidst a rediscovery of the great Greek and Roman thinkers, artists, and writers who had been lost during the chaos of the Middle Ages. This rediscovery motivated the wealthy intelligentsia to rediscover not only what had been lost for centuries but also to improve and expand on the discoveries and insights of the ancients.

The spirit of the Renaissance encouraged and supported new ideas and novel answers to basic questions. In a short period, this spirit began to spread, first within the universities and later throughout the major population centers of Italy. As innovative thinking blossomed in the arts and sciences, libraries expanded their collections and several metropolitan areas competed for the fame of claiming the great artists and thinkers of the Renaissance as their own. To this day, the names of these Italian cities remain synonymous with the art and education of their time: Florence, Milan, Assisi, Siena, Padua, Rome, and Venice.

Giotto the Painter

The intelligentsia of the thirteenth century could quote the names of several Greek, Roman, and medieval artists whose fame had spread throughout the Western world. Strangely, none were painters. Sculptors, architects, and potters had gained fame for their talents, but it was not until Giotto that painters finally had their first recognized master worthy of international recognition.

Some combination of events during the thirteenth century subtly set in motion a change in the way painters would execute their pictures for the next seven hundred years. Just as major cultural and political changes are associated with their innovators, art historians universally recognize Giotto as the catalyst for this change. Through Giotto's ability to experiment with new artistic principles and to apply fresh insights into the purposes of art, he initiated changes that would later place him on the same lofty pedestal with the best artisans that the Greeks and Romans ever produced. Art historian H. W. Janson confirms this view:

By infusing his works with perspective and emotion, Giotto di Bondone became known as the best painter of the early Renaissance.

> To his [Giotto's] contemporaries, the tactile quality of Giotto's art must have seemed a near-miracle; it was this that made them praise him as an equal, or even superior, to the greatest of the ancient painters, because his forms looked so lifelike that they could be mistaken for reality itself.[2]

Pastoral Beginnings

Sprinkled throughout the verdant landscape surrounding thirteenth-century Florence were dozens of picturesque hill towns. Few of these rustic towns were known beyond their modest borders, al-

though many gave birth to the great artists of the Renaissance. One such town, Colle di Vespignano, lies in the Mugello Valley not far from Florence and claims to be the birthplace of Giotto. Born from peasant stock circa 1276, Giotto di Bondone grew up knowing little more than how to care for goats and sheep, although many accounts claim that at an early age he demonstrated a quick and eager mind.

One day while tending his sheep, the youthful Giotto was whiling away the day sketching nature scenes in the dirt and on the smooth surfaces of rocks. It happened by chance that day that the most famous painter of the time, Cimabue, a nickname meaning "ox head," was passing through the Mugello Valley on foot headed for his studio in nearby Florence. Coming upon the young boy and seeing his sketches in the dirt, he recognized Giotto's latent potential as a great artist. Cimabue spoke with Giotto's father about teaching his son in Florence, and Giotto's father agreed to let him leave the hills for a life of art in Florence in about 1290.

Learning the Craft

Florence at the time when Giotto was a young teenager was already alive with art shops where artisans and their young apprentices worked on paintings, sculptures, and jewelry. Florentine society viewed art as a craft, not a respected profession, resulting in meager pay and low social status for artists and nothing but room and board for their apprentices. For lively minded Giotto, however, the excitement and variety of the big city captured his imagination, filling him with the artistic stimulation that he never would have experienced had he stayed behind tending sheep in the Mugello Valley.

Working with the master Cimabue, Giotto began to learn the craft of painting beginning with the basics. Giotto learned how to cut boards and fix them together to create panels on which he could paint. He learned to mix his own colors by grinding and mixing minerals, berries, flowers, insects, metal oxides, and scores of other materials for rich-colored pigments. He also learned how to make brushes of varying sizes and coarseness using the hair from various local animals. Before applying paint to walls for frescoes, Giotto and his compatriots learned how to clean the wall and then to prepare it by applying layers of sealant to prevent moisture from seeping through the wall and into the paint. Cimabue also taught the importance of carefully laying out the composition to ensure that it would properly fit the wall without crowding any of the figures and how to sketch the initial layout in charcoal prior to the application of paint.

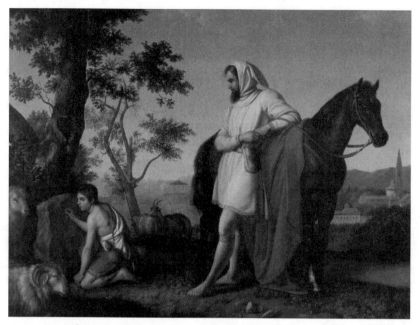

As a young boy, Giotto (left) served as an apprentice to Cimabue (right), who not only taught him the art of painting, but how to make paintbrushes by using the hair of local animals.

Although the work of an apprentice seemed hard, it did not dull Giotto's famous wit. Biographer Giorgio Vasari tells the following story to illustrate both Giotto's extraordinary talent as well as his sense of humor:

> It is said that while Giotto was still a boy, and with Cimabue, he once painted a fly on the nose of a figure which Cimabue had made. The fly was so natural that, when his master turned round to go on with his work, he more than once attempted to chase the fly away with his hand, believing it to be real, before he became aware of his mistake.[3]

This story illustrates not only Giotto's sense of humor but also a great deal of his self-confidence—two qualities that surfaced many times in his career. Whether Cimabue laughed at the joke is not recorded, but he clearly respected Giotto enough to allow him to travel to many cities around Florence to assist him with his paintings.

The Lure of Fame and Fortune

In his mid-twenties, Giotto executed a few minor paintings in Florence that greatly impressed leading art critics and prompted a few to regard his work more highly than that of his mentor, Cimabue.

Having established a minor reputation for himself in Florence and having pocketed some extra money, Giotto married Monna Cinta di Lapo del Pela, who bore him either seven or eight children. Little is known of his marriage, although it appears that the family often traveled with Giotto from commission to commission. As for his children, one son became a painter of little reputation, one daughter apparently married a painter, and all were considered homely, a characteristic attributed to their father's unattractive appearance. The writer Dante visited Giotto in Padua while he was painting the Arena Chapel and, noticing two or three of his children, asked how he was able to produce such beautiful paintings while producing such unattractive children. Giotto, in keeping with his reputation for being quick-witted, answered that he produced paintings by the light of day and children by the darkness of night.

Whether it was because of his growing family or his growing exposure to the wealthy art patrons of Florence, Giotto's wish to increase his income became a pronounced personality characteristic. So strong was his view on wealth that he openly expressed the opinion, contrary to many church leaders of the time, that poverty led to corruption, violence, thievery, and prostitution. Fortunately for Giotto, however, Pope Boniface VIII sided with his view and invited him to Rome to paint a series of minor works, including a painted crucifix, a painting depicting the prophets, and several other frescoes. Records indicate that the pope paid Giotto twenty-two hundred gold florins for several paintings and eight hundred gold florins for a fresco. The total for all of the work is lost, but these two amounts alone represent an enormous amount of money while illustrating Giotto's artistic fame.

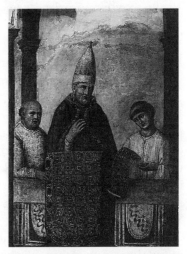

Pope Boniface VIII (pictured) invited Giotto to Rome, where he painted a series of minor works and enjoyed his growing fame.

In Giotto's later life, his pursuit of wealth was often noted by Vasari, who criticized him for attaining a social class in keeping with the leading bankers and merchants of Florence. Documents also portray Giotto as a man who did not hesitate to sue his adversaries over minor amounts of money.

As Giotto's fame grew, leading artists recognized that his paintings were pushing beyond the old tired art of the Middle Ages, creating an entirely new style, and heralding the beginning of the early Renaissance. During this critical time of transition, Giotto guided other artists out of the gloomy shadows of the Middle Ages and into the light of the Renaissance. Known for his technical innovation of rendering perspective in his paintings and for depicting biblical figures expressing emotion, Vasari made this observation about Giotto:

> In my opinion, painters owe to Giotto, the Florentine painter, exactly the same debt they owe to nature. . . . It was, indeed, a great miracle that in so gross and incomplete an age, Giotto could be inspired to such good purpose that by his work he completely restored the art of design, of which his contemporaries knew little or nothing.[4]

The Arena Chapel

By the time Giotto was twenty-nine in 1305, his reputation as an innovative artist was well established, prompting leading cultural centers throughout central and northern Italy to compete for his artistic genius. North of Florence, near Venice, the wealthy and powerful Scrovegni family sought Giotto's skills to decorate a new chapel they had built. Named the Arena Chapel, it had been built on the ruins of an ancient Roman arena. Attracted by the city's reputation for having a great university and lured by the opportunity to add to his growing bank account, Giotto accepted the Scrovegni commission.

The reason for building and decorating the chapel lay with the scandalous reputation of the Scrovegni family. When the elder leader of the Scrovegni family died some time around 1300, the local Catholic Church denied him a proper Christian burial because he had flagrantly practiced usury, charging excessive interest rates on loans. Without a Christian burial, the law prevented his children from receiving their inheritance. Enrico Scrovegni, the son, approached the bishop of Padua and was able to strike a deal whereby he agreed to build and decorate a new church for the city if the bishop would release his inheritance. Scrovegni learned of the remarkable talent of the young Giotto and invited him to come to Padua to paint the interior of the chapel. For Scrovegni, frescoes painted by a famous painter would bring him the additional status that his wealth and social position required. For Giotto, the work of painting the new chapel would fatten his bank

account and increase his reputation as a master painter. With this in mind, he arrived in Padua with his family to begin the most famous work of his entire career.

All artists have their magnum opus—the one masterpiece that expresses their genius above all others. For Giotto, the great work was the Arena Chapel. This chapel, neither unusually large nor having a distinctive architectural style, today houses one of the most renowned artistic treasures in Italy. Begun in 1305 and quickly completed one year later, Giotto committed himself to the daunting project of covering the entire interior of the sixty-seven-foot-long chapel.

A chapel this size—with its high walls, broad barrel ceiling, and only six small windows on one side—was a painter's dream. The subject Giotto chose to paint was the same subject that medieval painters had been executing for generations: scenes from the life of Christ. Before setting brush to wall, Giotto determined the layout of the subject matter. He divided the wall space into three horizontal bands around the perimeter of the walls. The top band,

In order to receive his inheritance, Enrico Scrovegni built the Arena Chapel in Padua. He invited Giotto to paint the interior, which he did with his most famous work—scenes from the life of Christ.

consisting of twelve panels, depicts events in the life of Jesus' mother, Mary; the second band, consisting of eleven panels, depicts scenes from the early life of Christ; and the third band, consisting of ten panels, depicts dramatic scenes leading up to and including his crucifixion. At the age of twenty-nine, Giotto displayed in these thirty-three panels perspective and emotion that would later elevate him to the status of the greatest painter of the early Renaissance.

A scene from the Visitation, *part of the top band of panels in the Arena Chapel, depicts Mary (left) after learning she is to bear the baby Jesus.*

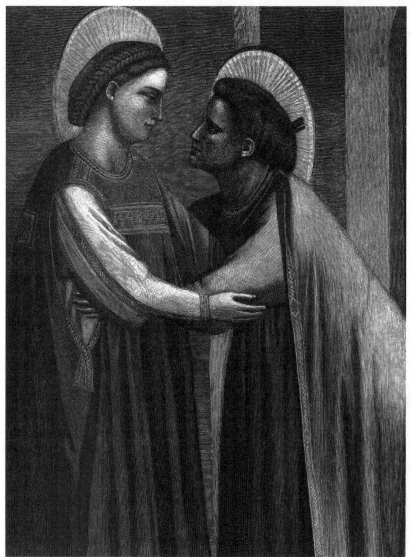

Giotto recognized that a work this size would require the assistance of several apprentices to mix paints, clean and prepare the walls, build scaffolding, and clean up at the end of each day. Lacking the artistic talents that he could easily have found in Florence, he began a school for artists in Padua both to provide for his own need for apprentices and to further the arts for the city. His practice of starting art schools continued throughout his life as he traveled, and it became one of the many reasons his fame spread throughout Italy.

As an innovator and leader of the early Renaissance, this commission presented Giotto with an opportunity to experiment with the two artistic features that brought him fame: accurate depictions of perspective and humanistic depictions of emotion. Giotto seized on this opportunity, completing all of the individual panels displaying these innovations.

Depicting Perspective

Giotto ingeniously applied the newly discovered principle of perspective in the panel the *Meeting at the Golden Gate*. In this scene, Giotto depicts the Virgin Mary's parents meeting on a bridge with women exiting a castle. In the background, the viewer looks through an arch to a wood frame of some sort. To the modern viewer there is nothing noteworthy about Giotto's depiction of this scene, but to a viewer living during the early fourteenth century, this composition was revolutionary.

The viewer sees in the *Meeting at the Golden Gate* the three-dimensionality of the castle. Rather than rendering the castle as a flat two-dimensional figure, Giotto gives it three-dimensional depth that the viewer sees at the corners; the walls in the foreground appear closer to the viewer than do those in the background. Giotto also demonstrated perspective in the positioning of the figures on the bridge. By making the two embracing saints taller and wider than the women in the background, Giotto was able to make them appear as though they were standing closer to the viewer.

Although Giotto had largely mastered perspective, he occasionally faltered trying to display it accurately. In the panel the *Pentecost,* Giotto struggled to represent the halos on the heads of the apostles. The story of the Pentecost, chronicled in the New Testament, describes the meeting between the Holy Spirit and Christ's disciples fifty days following the crucifixion. As the viewer follows the apostles around the table, the problem of the halos becomes evident.

For Christ and the apostles who are seated facing the viewer, Giotto's perspective works perfectly well; the halos are behind

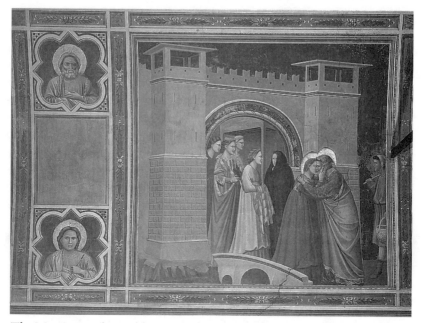

The Meeting at the Golden Gate *shows the Virgin Mary's parents. Giotto gave the figures perspective and the castle three-dimensional depth, which was revolutionary for his time.*

their heads so nothing comes between them and the viewer. For the four apostles who are seated at the table in the foreground and do not face the viewer, the situation gets tricky. Giotto solves the problem of three of the four by having them turn to one side, thereby depicting them in profile. For the one he paints from the back, however, the perspective of not allowing the halo to come between the viewer and the apostle's head creates a disaster. In this case, the apostle appears to be wearing his halo directly on his face, suggesting that he must look and talk *through* his halo—a comical scene to behold.

The Emotion of Humanism

Giotto's faces in the Arena Chapel show a departure from those of the Middle Ages, which lacked vitality and expression. The panel the *Adoration of the Magi* depicts the three wise men of the New Testament who follow a guiding star to Bethlehem, Jesus' birthplace. In the *Adoration of the Magi,* Giotto's expressive faces reveal many diverse feelings: happiness, amazement, and awe. Each of the three men has a slightly different expression. This panel is unique because it even shows the surprised, smiling face of a camel looking down in joy at the newly born Christ. Suggesting that a camel

might express happiness, especially juxtaposed to Christ, would have been unthinkable during the conservative Middle Ages.

Many art historians consider the most dramatic panel in the chapel to be the *Kiss of Judas,* sometimes titled the *Betrayal.* This panel highlights the moment that Christ confronts Judas, who will soon betray him to the Romans with a kiss as a signal that Christ is the man to arrest. Surrounded by dark and fiery symbols of conflict and chaos, Giotto centers the viewer's attention on these two men. Dramatically wrapping his cloak around Christ, Judas leans forward to kiss him. The two men, one representing good and the other representing evil, stand closely facing one another. Judas has a tense, worried look on his brow as he leans for the kiss. Christ, on the other hand, looks down directly into the eyes of Judas with a stern yet calm expression, signaling his premonition of the betrayal. The waving torches and wooden clubs underscore the tension between the two men.

The Arena Altar

The last great section of the painted chapel, the altar, depicts the Last Judgment. This panel is the largest one in the chapel. Executed in 1306, after Giotto had completed the wall panels, the *Last Judgment* brings the viewer back to a fundamental teaching

The Adoration of the Magi, *depicting the three wise men who follow the star to Bethlehem, shows expressive faces with diverse feelings. Even the camel has a surprised, smiling face as it looks down on Christ.*

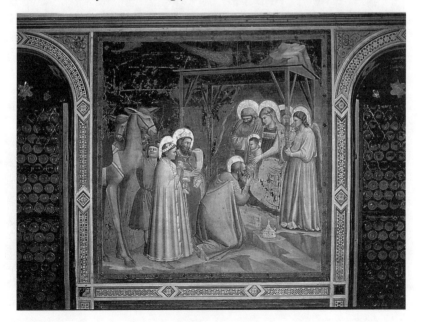

of the Catholic Church: Eternal peace and happiness in heaven await repentant sinners, but eternal pain and suffering in hell await the unrepentant.

A vivid circle of light, with Christ sitting in judgment, inscribes the focus of this work. To Christ's left and right sit the twelve apostles. With one hand he beckons the blessed to heaven and with the other he condemns the damned to hell. Regardless of Giotto's radical departure from the artistic expression of his forefathers, he did not take a radical departure from the spiritual teachings of the Church.

Although Giotto's artistic style was radical, the theme of the Last Judgment *adheres to the basic teachings of the Catholic Church.*

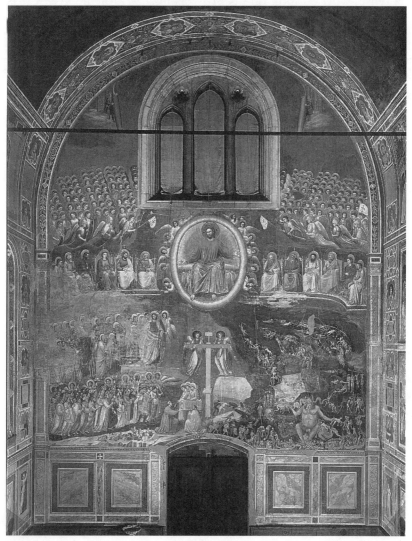

The two most interesting and dramatic scenes in the *Last Judgment* are the two lower quadrants; the right quadrant depicts a scene from hell and the left quadrant depicts the blessed lining up to enter heaven. Of the two, the scene of hell is the more riveting. Depicting the devil as a corpulent blue beast with parts of people hanging out of its mouth, it sits surrounded by naked men and women in various expressions of pain and suffering. Little blue devils are everywhere, pulling, clawing, and inflicting unimaginable torture on the damned. In the midst of this gruesome scene Judas, who betrayed Christ, hangs himself just to the left of the devil.

The lower left quadrant, depicting those ascending to heaven, is also interesting because Giotto has placed himself in this chorus along with the art patron who paid him to execute this extraordinary undertaking, Enrico Scrovegni. By including Scrovegni as the patron of the chapel, Giotto has created a bit of propaganda, depicting the family in a saintly light rather than as unscrupulous businessmen. Scrovegni is the person kneeling before the model of the chapel. Although Renaissance painters rarely signed their art, they often included themselves in their paintings; Giotto is the fifth person from the left in the bottom row.

An Ironic Twist

The historical record of Giotto's work following the completion of the Arena Chapel is uncertain; even Vasari has difficulty accounting for his whereabouts. Giotto apparently executed a few works outside of Florence, but he returned to the city in about 1310. The forty-three-year-old Giotto began work on a commission for the Ognissanti friars, who were known for living the simple life of raising sheep for their wool. Currently displayed in the Uffizi Gallery in Florence, this ten-by-six-foot painting on wooden boards is considered one of Giotto's finest works.

It was quite ironic that the fabulously wealthy Giotto would take a commission from the impoverished Ognissanti friars who raised wool. As Giotto's wealth grew beyond his ability to spend it, he purchased weaving looms that were quite expensive and rented them at outrageous prices to poor weavers who could not afford to buy their own. Profits for the rental of these looms often ran as high as 100 percent. The lure of riches apparently did not deter the once-poor shepherd from now making excessive profits from the very people with whom he had once lived. In spite of this irony, Giotto produced for the Ognissanti what many art historians consider to be his greatest work following the frescoes in the Arena Chapel.

The significance of the work, as is the case of all of his masterpieces, can only be appreciated in the context of its time, almost seven hundred years ago. The composition is the Virgin Mary holding the baby Christ in her lap while surrounded by saints and angels. To the modern eye, the painting appears stiff, cold, and dispassionate; and, indeed, it is when compared to the same scene painted by artists of the High Renaissance. Compared to Giotto's predecessors, however, it is revolutionary in its warmth and sensitivity.

Unlike previous depictions of Mary with her child, this one portrays her looking into the eyes of the viewer rather than down at Jesus. There is a calm about her face that is absent in older renderings of this scene. Her face expresses a human softness in the coloring of the cheeks, lips, and eyes. Giotto paints in great detail the realism of the weight of the child in her lap, which pulls her dress tightly across her body and outlines her breasts. The gradual movement from light areas to dark ones, as in the folds of her dress or the shadowing of her face, brought greater naturalness to this work than earlier painters could have achieved. Even the semitransparency of Mary's dress and Jesus' robe reveal Giotto's attention to detail, which was rarely found in earlier works.

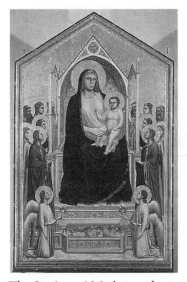

The Ognissanti Madonna *shows Mary looking into the eyes of the viewer rather than down at her son. Giotto's attention to detail brought warmth and sensitivity to the work.*

Giotto even treats the viewer to the lightheartedness of the two kneeling angels in the foreground. Their wings, rather than the usual white, have the vivid reds and yellows found on exotic tropical parrots. This touch surely must have been a visual treat for the citizens of fourteenth-century Florence. This rendering pushed realism farther along the path of accuracy than any other work of this era.

A Nomadic End

For the remainder of Giotto's thirty-seven years, he continued to travel to cities throughout Italy and even France to paint for wealthy patrons, including various popes. Sadly most of these works are

lost, but writers of the time who saw them describe a significant change from Giotto's early paintings of biblical themes. In keeping with the growing trend of the humanist and classical movements, Giotto's new paintings included Greek and Roman figures as well as the aristocrats of the time.

A few years after completing the *Ognissanti Madonna,* Pope Clement V invited Giotto to his temporary residence in Avignon, France. Although no painting exists to prove his presence in Avignon, Vasari claims that Giotto executed several paintings during his visit.

As Giotto's end drew near, his energy for work and his wit continued. In 1329 King Robert of Naples invited Giotto to his palace as a personal guest of the royal household. For the next four years, Giotto drew a monthly salary; the sum must have been extravagant, although it is not recorded. While in Naples Giotto painted several portraits of royalty and a few biblical scenes, all now lost. He also created an enduring friendship with the king, as illustrated by a witty exchange while Giotto was painting outside during the oppressive late afternoon summer's heat. Sensing Giotto's frailty, King Robert said, "If I were you, I would quit for the afternoon." Hearing his comment, Giotto snapped back, "So would I, if I were you."[5]

Giotto's last undertaking as an artist was the architecture of the Campanile, the bell tower of the Cathedral of Florence. His final resting place is in the corner of the cathedral closest to the bell tower.

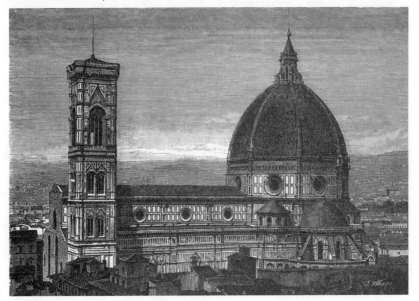

31

After finishing these commissions in Naples in 1334, Giotto returned to Florence for the last time. Respected as the most accomplished artist in all of Italy, the town council appointed Giotto superintendent of public works, a responsibility requiring him to give advice to the city council on all matters relating to the city's architecture. His last undertaking as an artist was as the architect of the 270-foot bell tower named the Campanile, which stands to this day. Odd as it may seem for a painter to design a building, Giotto had studied the architecture of many buildings before beginning his frescoes, and he had acquired a keen understanding of the engineering requirements.

Just eight days into the year 1337, Giotto died while working on the Campanile. His legacy to Florentine art earned him a resting place in the great Cathedral of Florence in the corner that was closest to the bell tower. There are no historical references to any of his children at his funeral, but thousands of people, both royalty and commoners, expressed their appreciation for the greatest early Renaissance painter, a man who began his life herding sheep along the footpaths of the Mugello Valley and ended it in the great Cathedral of Florence with this epitaph:

> I am he through whose merit the lost art of painting was revived; whose hand was as faultless as it was compliant. What my art lacked, nature herself lacked; to none other was it given to paint more or better. . . . But what need is there for words? I am Giotto, and my name alone tells more than a lengthy ode.[6]

Donatello the Sculptor

Beautiful free-flowing sculptures in marble and bronze were the domain of the Greeks as far back as the fifth century B.C. Famed throughout the Mediterranean, the names of the master sculptors were known to all. The Romans did nothing to further the development of sculpture; satisfied to copy it, and only poorly at that, the medium declined as they focused instead on engineering and architecture. Completely lost during the Middle Ages, the art of sculpture had declined to the point where works were mediocre renderings of stiff, lifeless forms.

This declining trend in sculpture was not reversed until Donatello rediscovered the Greek masterpieces and set about to improve on an already perfected art. Art historian H. W. Janson makes this observation about Donatello:

Early Renaissance art, in contrast [to the late Middle Ages] sought an attitude toward the human body similar to that of classical antiquity. The man who did most to re-establish this attitude was Donatello, the greatest sculptor of his time. . . . In a performance that truly marks an epic, the young Donatello has mastered at one stroke the central achievement of ancient sculpture. He treats the body as an articulated structure, capable of movement.[7]

Donato de Betto di Bardi, known as Donatello, was solely responsible for rediscovering the Greek masterpieces and resetting the trend of sculpture.

By the time Donatello had completed his career, contemporary Renaissance artists had declared him the greatest sculptor until Michelangelo, five generations later. Art historian Charles Avery also pays tribute to Donatello:

Donatello was the greatest sculptor of the Early Renaissance in Italy and one of the most versatile of all time, unmatched in his technical and expressive range. . . . Donatello was one of the key figures of the Renaissance. . . . His expressive portrayal of human character and relationships was noted in his own lifetime and it makes his work particularly appealing today.[8]

Early Life Within the Walls

Born within the city walls of Florence in about 1387, Donato de Betto di Bardi grew up as Donatello, meaning "Little Donato." Little is known about his family, although tax records of the time list his father as Nicolo di Bardi, and his occupation was a wool comber. A Florentine court apparently condemned him to death in 1380 for committing murder, but it later released him. By the time Donatello was twenty-eight in about 1415, his father had died. Historical tax records, filed by Donatello in Florence when he was forty-one, list as his dependents his eighty-year-old mother, Orsa, a sister named Tita, and her crippled eighteen-year-old son. Nothing more is known about Donatello's initial family, and no records or letters mention that he ever married or had children.

From Apprenticeship to Friendship

Donatello's early apprenticeship was as a goldsmith, not a sculptor, and it probably began in the workshop of the great architect Brunelleschi in 1399, when Donatello was about twelve. Although neither man's lasting fame is tied to goldsmithing, it was common for Renaissance artists to design jewelry as a way of paying rent when other more dignified work was scarce. This relationship between master and apprentice quickly evolved into one of Donatello's most significant lifelong friendships.

The friendship is easy to understand because both Donatello and Brunelleschi lived in Florence, each shared the same artistic interests, and each was a perfectionist at his craft. One biographer of Brunelleschi, Antonio di Tuccio Manetti, has an amusing way of explaining the friendship, suggesting that it existed because neither man had a wife or children, neither cared about what he ate or drank, and neither cared about the clothes he wore or where he lived.

There is good evidence that Donatello joined Brunelleschi on a trip from Florence to Rome in about 1402 to study classical Roman sculpture and architecture. Rome proved to be the perfect place for the sculptor and architect to study firsthand the works of the classical Roman masters. Although vandalism, earthquakes,

and fire had ravaged many of the Roman works, many bronze and marble statues remained, along with famous structures such as the Colosseum, the Circus Maximus, and the Pantheon.

Before Brunelleschi moved away from sculpting to pursue his interests in architecture, both men occasionally worked together on the same project. Both men apparently cooperated on a marble statue of St. Peter carved for the butchers guild. Evidence also exists of a payment made to both men for a small-scale model of a statue that they executed in a sculpting competition, which they did not win.

It was also during this early period of Donatello's life that the dark side of his personality first emerged. In 1401 Donatello got in a fight with a man and hit him with a large stick, which caused the man to bleed profusely. The court warned Donatello that if he acted in this belligerent manner a second time, it would fine him one hundred florins. Although there is no recording of another violent fight, Donatello's reputation for verbal threats and inappropriate outbursts became commonplace in later years. Even his best friend, Brunelleschi, was the target of his violent temper.

Early Discovery Period

At age seventeen in about 1404, Donatello received the opportunity to work as an apprentice at the shop of the most famous sculptor of the time, Lorenzo Ghiberti (1378–1455). At that time, Ghiberti was in the process of designing and executing his magnum opus: two enormous bronze doors for the Baptistery in Florence. Ghiberti won this commission in a competition against two other Renaissance artists, including the quintessential architect Brunelleschi.

These two doors, the second set to grace the Baptistery, consumed twenty years of Ghiberti's life. Each bronze door contains fourteen sculpted panels depicting scenes from the New Testament and focusing on events from the lives of Christ and his disciples. Completed in 1424, the doors were universally hailed as masterpieces. Ghiberti conceived the doors and executed them with the assistance of several students, one of whom was Donatello. This experience under Ghiberti left an indelible mark on Donatello's later works.

Donatello's first work that captured the attention of the art patrons of Florence was a larger-than-life statue of St. Mark. Donatello sculpted this marble work, which measured seven feet nine inches, between 1411 and 1413 for the Orsanmichele building in Florence. Sponsored by the guild of linen weavers and peddlers, art historians claim that it is the finest of his early works. The

work took Donatello more than two years to complete, although the contract specified that he finish the work within nineteen months. Donatello received the sizable sum of two hundred florins, twice as much as he had received for any of his previous large marble works, and more than five times as much for sculptures cut from stone softer than marble.

Most noteworthy about this work is the remarkably penetrating gaze of St. Mark. Begun when Donatello was only twenty-four, he had already started to surpass his teachers, Brunelleschi and Ghiberti, in rendering his subjects' faces and gestures. Not merely a man standing with a book, as medieval sculptors might have rendered him, Donatello portrays a saint of uncommon depth and integrity. Donatello accomplishes this by highlighting the face, deep in thought, which looks over the shoulder of the viewer. This focused look, combined with the highly stylized beard, set the standard for inner strength and moral righteousness, which would be copied by subsequent generations of sculptors. As art historian Charles Avery comments, "Michelangelo is reported to have said that he had never seen anyone who looked more like an honest man than did Donatello's figure, and that if St. Mark resembled this statue, his gospel should be believed!"[9]

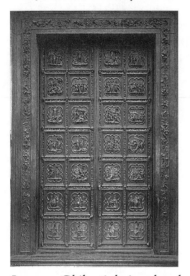

Lorenzo Ghiberti designed and executed two bronze doors for the Baptistery in Florence. The sculpted panels depict scenes from the New Testament.

In 1415 the guild of armor and sword makers in Florence commissioned Donatello to execute a statue of St. George, slayer of dragons, which stands today in the Museo Nazionale del Bargello in Florence. Thirty-year-old Donatello completed this marble statue, which measures six feet nine inches, in two years. The guild of armor and sword makers chose St. George as their patron saint because he was always depicted in full armor and holding a sword. The guild members intended this statue to function as an advertisement for their trade as well as a guild icon.

At about this same time, Donatello qualified as a master craftsman and opened his own shop. A document dating from 1416

indicates that he had begun teaching his own apprentices and allowing them to work on a few of his marble sculptures. In later years Donatello had as many as twenty apprentices assisting him with his many commissions, which he executed simultaneously. To accomplish so much work, Donatello assigned the rough-hewing of a wood or marble piece to junior apprentices. He would then work the more conspicuous parts of the statue and then turn the piece over to the senior apprentices for shaping the less conspicuous parts and final polishing. In this way, he had several works underway at all times.

Art historians see *St. George* as a bridge between the older style of the Middle Ages and the new style of the Renaissance. What is new, and therefore revolutionary, about this sculpture is the way St. George is positioned and the remarkably realistic expression on his face. Sculpted to stand in a niche, Donatello rotated the figure of St. George as he leans against his shield, projecting one shoulder forward rather than the traditional flat frontal view. For the viewer, this stance evokes body language suggestive of a person ready to do battle and confident in the outcome. The expression of this youthful-looking medieval warrior standing in a full suit of armor also reflects his confidence. Neither contorted in fear nor lost in hollow-eyed desperation, his eyes are fixed and his sword arm challenges his foe with his weapon, which has since been lost. Although encased in armor, St. George's stance suggests an athletic limberness commonly seen in Greek and Roman sculpture. Vasari comments on *St. George:* "For the Armourers Guild, he

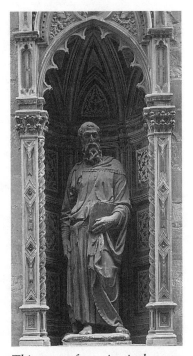

This seven-foot-nine-inch statue of St. Mark was begun when Donatello was only twenty-four. At this age he was already surpassing his teachers.

made a very spirited figure of St. George in armor, expressing in the head of this saint the beauty of youth, courage and valor in arms, and a terrible fervor. Life itself seems to be stirring vigorously within the stone."[10]

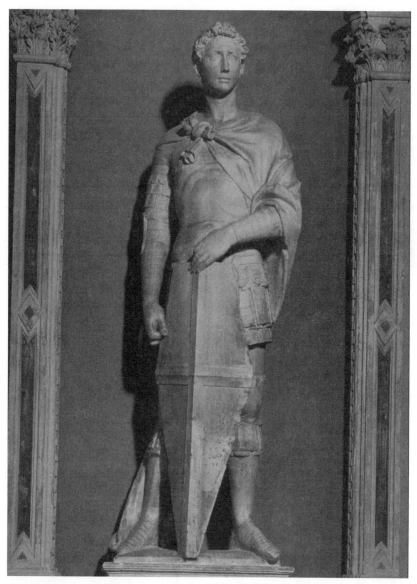

St. George exemplifies the realistic style of the Renaissance. A steadfast *St. George leans against his shield, suggesting he is confident and ready to do battle.*

Middle Innovative Period

By the time Donatello was in his late thirties, wealthy patrons throughout Italy were buying his sculptures. Most notably, the Medici family of Florence commissioned more of his works than any other single patron. The Medici family dominated the financial and political house of Florence for several generations, and their political

and social aspirations motivated them to acquire the best and most prestigious art of their time. Many of the works of Donatello and other artists were commissioned for their family estate, the Palazzo Medici, which later became the center for Florentine politics.

Donatello executed a four-foot-six-inch bronze, named *David*, for the Medici family. Although no records indicate how much the family paid for the bronze, Donatello received eleven hundred gold florins for a bronze door at about the same time. A significant increase over what he received from earlier works, it was modest compared to the twenty-two thousand gold florins Ghiberti received for his doors for the Baptistery. *David* is now housed in the Museo Nazionale del Bargello in Florence. Although art historians dispute the date of execution, they have pegged it at somewhere between 1430 and 1453. Considered by art historians to have been his magnum opus, *David* is also his most unusual work. So unorthodox is the piece that critics are incapable of unequivocally concluding what Donatello was trying to express in this, his most inscrutable commission.

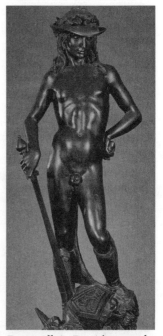

The most obvious characteristic of the work is its nudity. Although common and accepted by many Greek and Roman sculptors, during the Middle Ages nudity in art was confined to only two representations: Christ as a baby and renderings of Adam and Eve in the Garden of Eden. *David* is the first freestanding life-size nude sculpted in over a thousand years. Not only is it radical for its nudity, it is even more so considering its presentation. So imposing is the nude figure that many viewers fail to notice the head of Goliath beneath David's foot.

Donatello's David *was the first freestanding life-size nude sculpted in over a thousand years. At the time, nudity was confined to baby Jesus and Adam and Eve.*

Far from the radical look of *David*, Donatello executed his most massive statue, *Gattamelata*, between 1446 and 1450. Erasmo da Narni, a well-known Venetian mercenary, died in 1443 while in the Italian city of Padua. To commemorate his death, the city of Venice commissioned Donatello to create the only equestrian statue of his career. Today the statue stands in the

Piazza del Santo in Padua. *Gattamelata,* meaning "spotted cat," was a nickname for Erasmo da Narni, the man sitting astride the horse. This work proved to be Donatello's largest, measuring eleven feet two inches by twelve feet ten inches. As Donatello's fame as the greatest sculptor in all of Europe increased, so did his pay. The city of Venice paid him 1,650 gold ducats for *Gattamelata.* The ducat was the currency of Venice, and it was roughly equivalent to the gold florins.

Executed at the height of his career, this commission was an opportunity to rival the great bronze equestrian statues of the Romans. Donatello journeyed to Rome to study the equestrian statue of the emperor Marcus Aurelius, and a close look at the head, face, bearing, and weaponry of *Gattamelata* suggests a close approximation to the majestic emperor.

The horse in *Gattamelata* is an enormous beast, built to carry a warrior in full armor over rough terrain for long periods. It is similar to a Clydesdale, and would have weighed as much as a ton. Frozen in mid-stride, this massive charger moves forward with the authority and power of the man who sits astride its back. In this sense, Donatello captures the union of warrior and his trusted mount.

Donatello's most massive statue, Gattamelata, *caused financial and time pressures for the already temperamental artist. Overcome by frustration, he smashed the statue's head and had to recast it.*

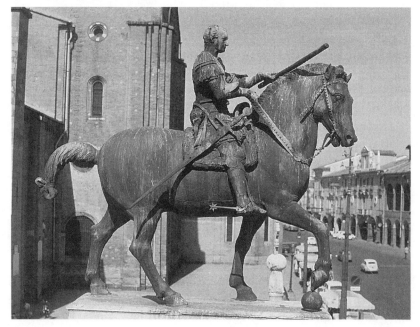

The size of *Gattamelata* created financial and time pressures on Donatello, causing his well-known temper to flare. Numerous squabbles arose, prompting Donatello to pick up the statue's head, smash it on the studio floor, and recast it.

Late Philosophical Period

Following the completion of *Gattamelata* Donatello accepted commissions in several northern Italian cities, but he returned to Florence in 1554 at about age sixty-seven. While in Florence, he continued working full-time and employed twenty apprentices to meet the demands of his patrons.

During Donatello's later years his works became more philosophical than those of his earlier life, focusing on biblical stories illustrating moral values. Living as a bachelor as he had all of his life, Donatello is not known to have had many close friends, except for Brunelleschi and his patrons within the Medici family, especially Cosimo de' Medici. Cosimo shared an intellectual and spiritual affinity with Donatello. Cosimo's wealth, power, and intellect made him the only man with whom Donatello dared not argue or offend.

Lost in the city's new trends in art and politics after his return to Florence, Donatello began work in 1454 on a wooden statue measuring six feet two inches. Wood was an unusual medium for Donatello, who normally

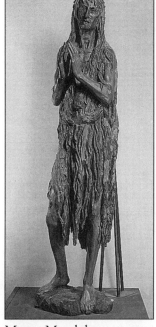

Mary Magdalena *was a horrid sight to some viewers, but it was Donatello's way of celebrating the inner beauty of the spirit.*

worked in either marble or bronze. That fact, combined with the shocking appearance and mystical gaze of the subject, speak to the extraordinary breadth of Donatello's skill.

This statue, titled *Mary Magdalena,* is now on permanent display in the Museo dell' Opera del Duomo in Florence. At first glance, most viewers recoil in horror at the freakish sight of this emaciated, leathery-skinned woman. Her scraggly mud-caked hair, broken teeth, and wrinkled skin were highlighted by paint and clay to accentuate the wood. There is a tendency to regard

this disfigured work as belonging to Donatello's early career, lacking skill and maturity, rather than at the end when his skills and perceptions were at their keenest. To draw such a conclusion, however, fails to understand the story of Mary Magdalene and the poetic genius of Donatello.

Mary Magdalene, a New Testament figure, was a prostitute befriended by Jesus. Mary gave thanks to Jesus by washing his feet with her hair. Later in life, after Jesus' crucifixion, it was Mary Magdalene and two other women who washed and anointed his body with oil before wrapping and placing it in a tomb. It is this inner beauty of the soul that Donatello asks the viewer to revere, not the outer beauty of the body. He sculpts her as the antithesis of physical beauty. His message to the viewer, as he neared the end of his life, celebrated the victory of the timeless spirit over the ephemeral flesh of a once physically beautiful woman now grown old.

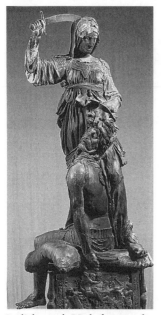

Judith and Holofernes *depicts Judith, a courageous Hebrew woman, about to decapitate Assyrian general Holofernes.*

Commissioned by Cosimo de' Medici as a centerpiece for a fountain in the garden of his private palace, *Judith and Holofernes* now stands in the Palazzo della Signoria in Florence. Donatello executed this seven-foot-nine-inch bronze statue between 1455 and 1460, making it, along with *Mary Magdalena,* one of his last works. An electrifying piece, it was another in a growing number of Renaissance works never intended for display in a church, monastery, or any other public place.

An Old Testament anecdote describes a beautiful Hebrew woman, Judith, who plays a decisive role in a war against the Assyrians. This story of daring and intrigue tells of Judith entering the enemy camp of the Assyrians, where she delights their general, Holofernes, who invites her to dine with him. While dining, he drinks too much wine and, falling into a drowsy stupor, Judith cuts off his head. As evidence of her act of bravery, she returns to the Hebrew camp and rolls Holofernes' head out of a bag as proof of his death. The next day the leaderless Assyrians suffered a defeat at the hands of the Hebrews.

The extraordinary power of this piece is evident to the viewer looking up at the act of decapitation, frozen an instant before the fatal sword blow falls. Gazing on this statue, the power of the work rests with the woman in mid-swing of her sword. She stands over Holofernes, pulling his head upward by his hair while pinning him to the ground by standing on his wrist so he cannot escape his inevitable fate. Holofernes, juxtaposed to Judith, looks dazed, entirely incapable of comprehending the finality of the moment. Art historians believe that Donatello is teaching the Greek concept of hubris, the sin of excessive pride, often translated as conceit or arrogance. Greek philosophers taught that excessive pride would always be punished by a tragic act, usually death.

A Somber End

The last six years of Donatello's life in Florence lack much historical information. Requests continued to pour in from art patrons throughout Italy, but for unknown reasons he did not respond. A few works underway were never completed. The best guess that art historians have rests with a comment by Vasari that Donatello spent his later years ill in bed until his death on December 13, 1466. Following his funeral, he was buried next to his friend Cosimo de' Medici in San Lorenzo, just as he had directed in his will.

At the time of his death, Donatello had completed seventy-eight known major and minor sculptures. No records indicate that any of the money he had made was in his bank account. It appears that although he lived a frugal life as a bachelor, money had little value to him, and he probably gave much of it away before his death.

Despite Donatello's difficult personality, he received the highest accolades afforded any early Renaissance sculptor. Like the painter Giotto, he subscribed to the new principles of the early Renaissance, portraying emotion, proper perspective, and the influence of classical sculptors. Toward the end of his career he added dramatic action to his figures and used his sculptures to teach moral lessons. Nearly all Renaissance masters expressed their indebtedness, at one time or another, to his revolutionary work. Art historian G. Gaeta Bertelà makes this observation: "We feel ourselves trespassers among [Donatello's] private beliefs and personal emotions, as we do in San Lorenzo [Donatello's crypt] when we read the pages where an artist's soul is for the first time laid bare."[11]

Brunelleschi the Architect

Across from the beautiful Arno River that runs through the heart of Florence rise verdant rolling hills where Florentines go to enjoy the best panoramic view of their city. Florence is famous for its red-tile roofs, but the most recognizable roof in the city's modest skyline is Filippo Brunelleschi's most famous achievement: the elliptical dome on the church of Santa Maria del Fiore. Rising 297 feet above the narrow cobblestone streets and busy sidewalks, this massive dome is the dominant landmark in Florence.

His magnum opus, the dome is frequently referred to in art books as the eighth man-made wonder of the world. It is, by itself, sufficiently remarkable to secure Brunelleschi's place in the pantheon of great Renaissance artisans. As art historian Heinrich Klotz contends,

> Brunelleschi's dome was the first in a whole series of post-medieval domes. With it the "monumental" form of modern architecture was born. Even the domes of the state capitals in America have their roots in the Florence dome. Thus Brunelleschi's edifice has to be seen as *the* building that marked the end of the medieval period.[12]

A Good and Honorable Beginning

Born in Florence in 1377, the few words we have regarding Brunelleschi's parents come from the biographer Antonio di Tuccio Manetti, who tells us that "he [Brunelleschi] came from good and honorable people."[13] Brunelleschi's father worked in Florence as a notary, and he taught his son Latin and how to use the abacus for mathematics. As a child, Brunelleschi was obedient and manageable, exhibiting a natural interest in drawing and painting. As to appearance, he was considered physically unattractive. Vasari describes Brunelleschi as a man whose physical characteristics were "insignificant to look at but his genius was so commanding that we can surely say that he was sent by heaven to renew the age of architecture."[14]

Brunelleschi began his career as an apprentice to a goldsmith when he was about thirteen, and he showed a strong aptitude for the trade. He quickly graduated to sculpting small silver works and tried his hand at carving religious relics such as crucifixes out of wood. After considerable and rapid success, Brunelleschi began to study architecture; his natural genius led many to seek his advice on design and construction.

While in Rome, Brunelleschi studied the architecture of several buildings, replicating them to scale and paying close attention to the mathematics involved.

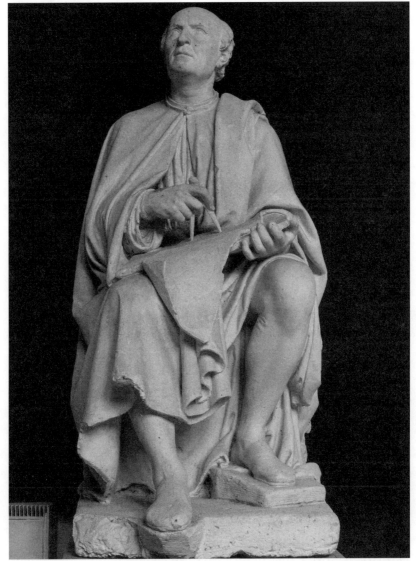

In 1401, at the age of twenty-four, Brunelleschi was confident enough to enter a competition authorized by the city council of Florence to select a sculptor to execute a major work: two sets of large bronze doors for the Baptistery. The seven leading sculptors of the time, including Brunelleschi and Ghiberti, competed for the honor by submitting samples of their work. When the time came for the judges to render their decision, they awarded a joint commission to Ghiberti and Brunelleschi. Brunelleschi, in keeping with his unyielding personality and his need to take complete charge of his commissions, refused the offer.

Binding Ancient Rome with Modern Florence

Following Brunelleschi's refusal to work with Ghiberti, he and his close friend Donatello went to Rome in 1402 to study classical sculpture and architecture. It was during this visit that Brunelleschi studied the walls, domes, arches, and columns of the great theaters, palaces, and temples of ancient Rome. While trying to understand how the Romans had designed these master works, he began drawing them to scale in the dirt. As he drew them, he began to see ratios, or mathematical relationships, between all parts of a building. H. W. Janson, a modern art historian, pays tribute to Brunelleschi in his book *History of Art:* "The new architecture . . . did owe its existence to one man, Filippo Brunelleschi. He studied the architectural monuments of the ancients and seems to have been the first to take exact measurements of these structures."[15]

Brunelleschi's quest as an architect, in keeping with the tradition of Giotto and Donatello, was to bind the craft of the ancient Roman architects with those of modern Florence, a span of more than a thousand years. Biographer Giorgio Vasari understood Brunelleschi and his connection with the ancient Romans. "By means of the study and the diligence of the great Filippo Brunelleschi, architecture once again discovered the measurements and proportions of the ancients,"[16] he comments.

Brunelleschi was the first Renaissance figure to understand that accurate perspective is directly tied to mathematics. So significant was his discovery for architects, sculptors, and painters alike that all Renaissance artists following him paid homage to the genius of his discovery. The essential discovery to understanding perspective is its mathematical relationship of scale.

Scale is simply a ratio of the sizes of two objects. Brunelleschi realized early on in his career that when drawing or constructing a model of a building, he could accurately represent correct perspective. Knowing that figures closer to a viewer appear larger and

46

Brunelleschi (standing, right) and Ghiberti show a model of the church of San Lorenzo to Cosimo de' Medici. Brunelleschi used models to gain perspective on his work.

more detailed than those farther from the viewer, Brunelleschi precisely calculated the size of all figures and forms in a painting or scale model based on their size and distance from the viewer. By maintaining the same ratio for all parts of a painting, sculpture, or building, the object would look natural to the viewer.

The Craft of the Architect

Of the three major art forms—painting, sculpting, and architecture— the last of these carries with it the greatest complexity. The craft of architecture, like that of painting and sculpture, focuses on an appealing and meaningful aesthetic presentation for public viewing. Unlike painting and sculpture however, it must also guarantee the safety of those visiting and admiring the buildings. Great cathedrals must be capable of withstanding the stress of their own crushing weight as well as seismic activity to ensure that their thousands of tons of stone and concrete do not collapse. The genius that brought Brunelleschi fame as the greatest Renaissance architect was his ability to couple mathematics and engineering with his artistic proclivities.

Brunelleschi began his great works of architecture by first determining the correct perspective for the project. For the architect, the correct perspective meant understanding how the building would appear to people looking at it. In the case of small buildings, it meant a ground level perspective with only a slight upward viewing angle. For monumental architecture, however, the viewing angle is dramatically upward. Vasari writes about Brunelleschi's attention to perspective:

> Filippo made a careful study of perspective which, because of all the errors of practice, was in a deplorable state at that time. He worked for a long while until he discovered for himself a technique by which to render it truthfully and accurately, namely by tracing it with the ground-plan and profile and by using intersecting lines.[17]

As important as perspective, the architect also needed to determine the correct proportion of one part of a building relative to all others. Correct proportion involves ensuring that all parts of a building are the proper size *relative* to each other. Entry doors must be in proportion to the height of the walls, which must be in proportion to the length of the walls, which must be in proportion to the width of the building, which, in turn, must be in proportion to the size of the dome.

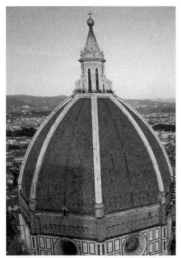

With the aid of a model representing all the parts of the dome, Brunelleschi was able to convince people that his idea to build the Duomo would work.

The Dome of Santa Maria del Fiore

Begun in 1296, Santa Maria del Fiore, commonly referred to as the Duomo, meaning "house of God," is the principal cathedral in Florence. Arnolfo di Cambio (1245–1302), its first architect, began the project that many other architects worked to complete 140 years later in 1436. The construction of the walls was completed in 1336, and the dome was ready to be added. The architects realized that the dome over the octagonal choir would be tricky. The proposed dome, 140 feet in diameter and 297 feet above the floor, would be the largest in the world.

While the architects of di Cambio's time understood the projected size and height of the dome, none knew how to build it. The dome of the Pantheon in Rome, although the same diameter, was not as high off the ground, making it much easier to construct. The man who would eventually conceive the mathematics needed to support such a tremendous weight, and the mechanics to put it in place, Filippo Brunelleschi, had not yet been born.

The architects and engineers in Florence and Rome wrestled with the problem of supporting the tremendous weight of a dome spanning such a large open space without one or more center supports. Brunelleschi was the only architect who believed it could be done. Brunelleschi, sensitive to the need for the lightest possible materials, conceived of two shells to reinforce each other rather than one solid stone and concrete dome. The internal skeleton of cross-braced ribs has eight that are visible on the exterior and sixteen concealed within the two shells.

A Caustic Tongue

In 1418, when Brunelleschi was forty-one, he was unable to find other architects who would defend his idea of constructing a dome without the use of center posts. Attempts on his part to explain the engineering had led to open conflict with many of his colleagues, which hindered his cause. Twice, historian Manetti tells us, Brunelleschi had to be physically carried out of the hearings by guards.

Brunelleschi had a difficult personality that made him argumentative, caustic, and secretive. These antisocial characteristics sent him to jail for eleven days in 1434 because he refused to pay an annual fee to belong to the stonemasons and woodcutters guild. Brunelleschi maintained a lifelong hostile rivalry with his contemporary, the Florentine sculptor Lorenzo Ghiberti, with whom he had competed for the commission to sculpt the bronze doors for the Baptistery in 1401. Unfortunately for Brunelleschi, the commission awarded twenty-two thousand gold florins to Ghiberti; one of the largest ever awarded. Brunelleschi's sarcasm towards Ghiberti once spilled over when someone asked him what the best thing the sculptor Ghiberti ever did. Brunelleschi replied that it was to sell the house that he had owned. Brunelleschi's anger was not reserved exclusively for fellow artists, however. Once, in a fit of anger after listening to criticism of a palace model he had built for his patron, Cosimo de' Medici, Brunelleschi picked up the model and smashed it to the floor.

After much bitter conflict, Brunelleschi decided to win over badly needed support by building a scale model of the dome rather than merely drawing it. With the aid of a model, Brunelleschi was able to represent accurately the relationship of all parts of the dome. The advantage of the model was that it allowed all viewers to see and experience the dome from all sides by simply walking around the model, unlike his drawings that only represented one view.

Brunelleschi's constant rivalry with Lorenzo Ghiberti (pictured) began when they were both commissioned to sculpt the Baptistery doors.

An Egg

The dome model that Brunelleschi crafted was not round like that of the Pantheon, but rather it was elliptical, like an egg standing on end. Brunelleschi recognized that a round dome would not hold up, as Vasari retells one of his presentations to the architectural committee:

Sires, in taking into consideration the difficulties of this structure, I find that it is impossible for anybody to make it perfectly round, seeing that the space over which the lantern [the cupola on the top of the dome] is to go would be so great that, when any weight were put there, the whole would speedily fall down. . . . I accordingly resolve to make the inside of the vault in sections, corresponding with the outside, adopting the manner of the pointed arch . . . and when the weight of the lantern is imposed, the whole will be made durable.[18]

Brunelleschi's design of an elliptical pointed dome would withstand the downward lateral forces. Much of the beauty of this dome derives from its egg-shaped design. Unlike the relatively low-profile, flat dome of the Pantheon in Rome, which cannot be seen from the streets, Brunelleschi's dome rises vertically in full view of passersby on the streets below. With its long, beautiful vertical lines and terracotta tiles capped by a tall, thin white cupola, this dome is a Renaissance beauty. L. B. Alberti asks the rhetorical question,

Who is so dull or jealous that he would not admire Filippo the architect in face of this gigantic building, rising above

the vaults of heaven? It is wide enough to receive in its shade all the people of Tuscany, and built without the aid of any truss work or mass of timber.[19]

Brunelleschi realized that the weight of the dome would place extraordinary pressure on the supporting walls. Concerned that they might buckle under the weight, Brunelleschi recommended building a ground-level ring of chapels around them. Not only did Brunelleschi solve a difficult engineering problem, but he also did it with remarkable artistic style.

Satisfied that Brunelleschi's elliptical dome would stand without center supports, the architectural board awarded him the commission. Unfortunately, the documents that detail his salary and the amount of time within which the dome was to be completed are

Brunelleschi's elliptical pointed dome rises to full view of any passerby. To compensate for the weight of the dome, he designed a ring of chapels around the supporting walls.

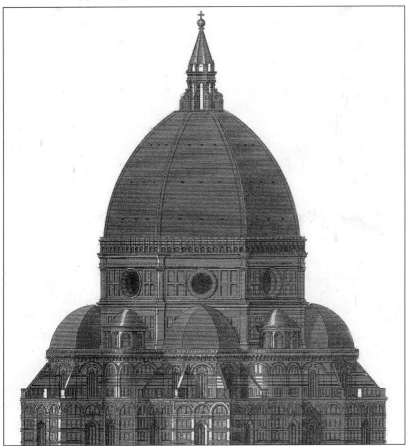

lost. The only existing detail regarding payment is a reference to one hundred florins paid to him for some hoisting machinery he invented.

Around this time Brunelleschi adopted a five-year-old son called Il Buggiano. The only reference to this son is when he was a young man of twenty-two and he stole money from his father and fled to Naples. After this nefarious event, Buggiano apparently returned to his father's good graces because he inherited his father's estate and carved a wooden effigy of his father for the funeral.

An Eye for Detail

Brunelleschi had an eye for detail and enhanced the beauty of the dome with intricate stone and marble work in keeping with the Renaissance tradition. During his life as a goldsmith, sculptor, and architect, no gem, stone, or brick was set in place without his careful examination to be certain that it was correct and carefully cleaned. Manetti claims that Brunelleschi even paid close attention to the

Brunelleschi had an incredible eye for detail. It is said that he even inspected the sand that was to be made into concrete.

concrete that he used and that he "personally inspected the sand and lime mixture [for the concrete] whenever it was required."[20]

Although the dome is the dominant landmark in Florence, Giotto's Campanile, built nearly one hundred years earlier, has seniority. Its close proximity convinced Brunelleschi to cover the exterior of the dome with the same white and green marble. Brunelleschi decorated the transition of the barrel (the rim on which the dome rests) and the spring of the dome with a delicately conceived marble balustrade around the perimeter of the barrel. Tragically, much of this beautiful detail collapsed many years ago. Although Brunelleschi knew that few would make the climb to the cupola, he nonetheless supported it with beautifully carved flying buttresses. These structural supports are the stone arches that apply pressure to the cupola walls to prevent them from buckling under downward pressure.

A dome of this size and heft has little room for weak window structures needed to illuminate the cavernous interior. Lacking electricity, sunlight and candles were the only light sources, and of the two, candles had little effect in a cathedral this size. To illuminate the interior, Brunelleschi designed three types of windows. At the top of the barrel he set eight large round windows. These were safe because the pressure on them was vertical. Above the barrel Brunelleschi set nine very small windows in each of the eight sections. These could not have been larger because of the intense downward and outward pressures of the dome. Larger windows would have weakened the sides, causing them to blow out. Finally, at the cupola on top, Brunelleschi set eight long thin windows. These windows were made possible because the cupola is under very little pressure. Architects often refer to the cupola as the lantern because it is a major source of light.

Erecting the Dome

Work erecting the dome began in 1420, two years after Brunelleschi built his model. Engineering the dome was only one impediment, the other was discovering how to erect it. How would workmen move the thousands of tons of stone and concrete to a height of 297 feet above the street, connect all of this material into a single dome, and permanently hold it in place? What underlying structure could hold the dome in place until the concrete dried? Brunelleschi gave much thought to these vexing engineering questions.

One proposal recorded by the historian Vasari, probably a whimsical one, suggested that the interior of the cathedral be filled with dirt to the required height. Once in place and compacted, the dome would be built on top of the dirt, which would support the dome's weight until the concrete could dry. When the concrete had hardened, the dirt could be removed, leaving behind the freestanding dome. When someone asked about the cost of removing the dirt, some unknown person proposed scattering coins throughout the dirt to motivate children and others to remove it at no cost beyond the coins.

Brunelleschi waded into this engineering fray suggesting the novel use of scaffolding—wooden beams and planks cantilevered from the surface of the dome on which workers could stand while toiling dangerously high above the streets. Brunelleschi wagered that by using scaffolding, workmen could safely pull up needed materials, put them in place, and move the scaffolding up as the dome progressed.

The cupola's tall vertical windows are the Duomo's main source of light.

The scaffolding solved the problem of supporting the workmen as the dome rose, but Brunelleschi also needed to turn his engineering energies towards solving the problems of hoisting the stone blocks and concrete. To solve this problem, he began sketching ingeniously designed cranes, winches, and other machines for lifting needed materials to the top of the dome. Documents recorded during construction indicate that oxen-driven lift machines were capable of hoisting an average of fifty loads a day, varying from small loads to several tons.

Not until the advent of the Industrial Revolution some three hundred years later did anyone develop machinery more sophisticated than Brunelleschi's.

A Cruel Fate

Brunelleschi's fame is almost entirely tied to his dome in Florence. Unknown to most people are the many smaller yet important buildings he also designed. Art historians credit him with about fourteen major architectural works, including palaces, hospitals, and fortifications for several cities.

Fate can play cruel tricks on people, even on great ones like Brunelleschi. In 1446, after eighteen years of work on the dome and twenty years away from completion, he died.

Brunelleschi's genius and reputation were so great that when he died the magistrates of Florence voted him the honor of burial under the dome that he had worked on for so many years. At his funeral the mighty and the lowly came from miles away to pay their respects to his genius and his generosity. Vasari tells us that it was the poor artists who were especially touched by Brunelleschi's death because he had given them so much assistance and encouragement at no cost.

In 1972 historians discovered his tombstone in the cathedral, which reads, "CORPUS MAGNI INGENII VIRI-PHILIPPI S. BRUNELLESCHI FLORENTINI"[21] (The body of a great brilliant man-Filippo S. Brunelleschi of Florence).

Leonardo da Vinci the Innovator

Within the relatively large garden of geniuses that flourished amid the intellectually fertile soil of the Renaissance, probably none left confirmation of greater diversity of thought and greater willingness to explore unorthodox ideas than did Leonardo da Vinci. Fueled by incontrovertible logic in matters of mechanics and engineering, stimulated by the wonders of physics, and charged by emotional revelations of the innermost secrets of the soul, Leonardo was the quintessential "Renaissance Man."

In terms of productivity in the arts, other Renaissance masters produced far more paintings and sculptures than Leonardo, but none can lay claim to a greater breadth of intellectual curiosity. Leonardo's nonartistic interests in mechanics, anatomy, and engineering actually exceeded his artistic interests. Leonardo's books, more than seven thousand pages of notes and fifteen hundred drawings, contain notes and sketches of architecture, human and animal anatomy, weaponry, various mechanical devices, perpetual motion machines, fortifications, river rechanneling, and a myriad of other scientific doodles.

Leonardo da Vinci's interests expanded well past the arts into anatomy, weaponry, engineering, and river rechanneling, making him a real "Renaissance Man."

The early Renaissance can be generalized as a time when virtuoso artists broke from the artistic traditions of the Middle Ages and concerned themselves with humanism, classicism, and defining rules for proper perspective. The High Renaissance can be generalized as a time when artists focused their talents on perfecting what the early masters began

and adding greater visual accuracy and style. Of the High Renaissance masters, Leonardo da Vinci was the chief innovator.

A Peculiar Mind

On the slopes of Monte Albano, up the beckoning heights to the west of Florence, the rural town of Vinci holds claim to the birthplace of its most famous native, Leonardo da Vinci, who took his last name from his birthplace. Born illegitimately in 1452, Leonardo's father, Piero, was a notary who died at age seventy-seven after having married four women and fathered twelve children. His mother, Caterina, was a peasant worker about whom nothing more is known.

From the time of his birth, most of Leonardo's youth seemed to be uneventful, except for a few years when his father sent him away to live with his grandparents. His education was standard for the time, studying mathematics, Latin, and literature, although his interests seemed to be in biology and physics. Leonardo excelled at these two interests, developing peculiar traps for small animals so he could study them. The keen sense of detail and observation that is evident in Leonardo's later paintings and scientific drawings came from these early interests.

Under the apprenticeship of Andrea del Verrocchio (pictured), Leonardo learned sculpture and painting, concentrating on the latter.

Another peculiarity he developed at an early age was the knack of writing from right to left with the letters reversed. When Leonardo's friends wished to read his letters, they held them up to a mirror to reverse the letters and words. Leonardo maintained this eccentricity of using "mirror image" writing all of his life.

In 1469, when Leonardo was seventeen, his father recognized his growing artistic talent and unorthodox thinking and took him to Florence to study as an apprentice in the studios of the masters. Considered rather old to be starting out as an apprentice, Leonardo was fortunate to study with the master artist Andrea del Verrocchio (1435–1488), who accepted him into his studio and taught him painting and sculpture.

Leonardo worked in Verrocchio's shop for the next seven years. Although he helped with oil paintings, he refused to work on frescoes or to take part in goldsmithing, both of which were common pursuits at the time. Concentrating on the paint medium allowed Leonardo the opportunity to explore innovative ideas in paint application, color, and exceptional realism. By age twenty-three Leonardo was the chief assistant in Verrocchio's shop; however, his works continued to be relatively minor, giving him a late start on his career. In 1481 Leonardo finally began his first major work, *Adoration of the Magi*, just before departing Florence for Milan.

In that year, when Leonardo was twenty-nine, Pope Sixtus IV drew up a list of the best Florentine artists to work in the Vatican, but Leonardo was not on the list. Feeling scorned and unable to see an expanding horizon for his talent, this great thinker traveled north to Milan, where he soon found the recognition that had eluded him in Florence.

An Exile in Milan

Leonardo left the progressive arts of Florence for the more conservative arts of Milan. Upon his arrival, the wealthy and powerful patron of the arts Ludovico Sforza immediately hired him. This fortunate event presented Leonardo with an avenue into Milanese society, where he was warmly welcomed. The Sforza family gave Leonardo an apartment in their palace, and he quickly won the friendship of the entire family. For Leonardo, this was the good fortune that had escaped him in Florence.

Ludovico ruled Milan as a tyrant, controlling both the people and the economy. He enjoyed spending huge sums on gala parties, jewelry, art, and decorating his palace. Leonardo hoped to find Ludovico a more generous patron than the de' Medici family in Florence. In this regard, Leonardo was bitterly disappointed. Although Ludovico controlled great wealth, little of it found its way into Leonardo's pockets. He did have the opportunity to work on new innovations for painting, which brought greater detail and accuracy to that medium. These innovations proved to be highly successful, and master painters who followed him copied them. Although the pay was unsatisfactory, Leonardo's lifestyle in the palace was high living. While there, Leonardo began one of his few significant friendships, which lasted for twenty-five years. When Leonardo was thirty-eight, he hired a ten-year-old boy as one of his apprentices. By all accounts the young boy, nicknamed little Satin by Leonardo, had little artistic talent, but Leonardo found him to be a "graceful and beautiful youth." [22] As time passed, the

Ludovico Sforza (pictured) hired Leonardo as soon as he arrived in Milan. Although Sforza gave Leonardo an apartment in his palace and welcomed him into Milanese society, Leonardo found his new patron's pay unsatisfactory.

young man caused Leonardo problems because of his penchant for thievery. Leonardo constantly paid for items he stole and recorded in his letters the clothing he bought for him. When Leonardo later left Milan for Florence, he took the little Satin with him; little more is heard of him until Leonardo's death, when a vineyard was left to him in Leonardo's will.

Innovations

Two of the new techniques designed to convey visual nuances were chiaroscuro, meaning "light and dark," and sfumato, meaning "smoke." The former of these techniques uses the intersection of

light and dark in a painting to create forms that seem to mystically appear and disappear into the background. Clearly defined lines separating forms common to the Middle Ages and early Renaissance disappear in favor of a unity of many forms blending and losing their individual identity. The latter of the two techniques requires multiple layering of oils to create a misty, dreamlike effect that brings poetic warmth to a scene. These two techniques were largely unknown to the early Renaissance painters.

Leonardo's unique position as a leading artist is also due to the exceptional detail in his work. His exquisite renderings of people's facial and body expressions to reveal their thoughts and feelings, one of the hallmarks of his works, was the result of his careful anatomical drawings.

Leonardo acquired a dubious reputation for having started many art works that he never completed. This predilection was due in part to a streak of impatience with works that were taking longer than anticipated and a tendency toward distraction. In his sixty-seven years he began scores of paintings but completed only twelve and one sculpture. The sculpture, a mammoth horse and rider similar to the one done by Donatello, was shot full of holes by invading French archers, causing it to fill with rainwater and collapse from corrosion.

Adoration of the Magi

It was here in Milan that Leonardo finally found the time and money to continue work on the *Adoration of the Magi,* which he had begun in Florence. Sketched out in Florence but continued in Milan between 1481 and 1482, art historians consider the *Adoration of the Magi* to be the masterpiece that marks the beginning of the High Renaissance.

This painting, now hanging in the Uffizi Gallery in Florence, is but one of large number of Leonardo's major works that he never completed. Nonetheless, this work is of interest to art historians as one of Leonardo's earliest works and one that artfully displays both of the new painting techniques of chiaroscuro and sfumato. Executed before the use of canvas, Leonardo painted it on wooden boards fastened together.

Although the work was never completed, Leonardo's application of chiaroscuro is artfully rendered in the group of admirers to the right of the viewer. The masterful use of light tones, deftly applied as little more than isolated lines and swirls in the depth of dark tones, give only vague outlines to the many people in this crowd. They appear to be a boiling mass mystically swirling out of

the darkness, drawn to the light tones of Mary and Christ, who form a triangle with the figures to their left and right. True to the intent of chiaroscuro, we see a general surge of shadowy figures without seeing the individuality of each one. This effect creates a surreal emotional continuity as well as a three-dimensionality of the figures; it was never attempted by the early masters of the Renaissance, who isolated each figure by carefully outlining it.

The background of this work, never completed, drifts into the forms of nature. The distant trees, mountains, and horses exist within the rough sketching of the technique of sfumato. Leonardo achieves this hazy effect by applying many layers of paint at higher elevations in paler, more transparent tones than those close to the land.

Principally a painter, Leonardo soon found Sforza asking him to design military machines and fortifications for Milan. Leonardo apparently drew and designed much but built nothing. His frustration became evident when he complained to Sforza, "It vexes me greatly that having to earn my living has forced me to attend to small matters."[23] It was at this time that Leonardo sculpted the colossal equestrian statue that French archers later destroyed.

One of the many works that Leonardo did not complete was the Adoration of the Magi. *Though unfinished, it is considered a masterful example of chiaroscuro and sfumato.*

A Legacy of Art

Within the few years spent with the Sforza family in Milan, Leonardo completed more paintings than in any other period of his life. Ludovico commissioned Leonardo to paint his mistress, Cecilia Gallerani, in 1484. When Leonardo painted the portrait of her holding an ermine, she was only seventeen years old. Now hanging in the Czartoryski Gallery in Kraków, Poland, this work is a classic example of Leonardo's blend of people and nature.

The background of the painting, always important to Leonardo, is stark black. It lacks the sfumato technique usually applied to his distant scenes of nature, highlighting mountains, trees, and bodies of water. The dramatic contrast of the severe black background, juxtaposed next to the young woman's exquisitely attentive porcelain face and delicate fingers, identify Leonardo as the master painter of this dramatic effect.

Cecilia's face turns away from a frontal view to present to the observer a rather rare three-quarter portrait. The look that Leonardo captures is that of an intelligent, highly focused young woman; her inherent youthful beauty is not portrayed by a smile or a glance, but rather in her smooth skin and facial bone structure. She looks off to her left, focused beyond the purview of the observer, oblivious to the fact that the ermine she strokes is striking a menacing pose.

Leonardo was one of the first artists to portray humans sharing a relationship with animals of greater significance than one of merely providing food or work. Leonardo did not choose the ermine but painted it into the picture because it was the symbol of the Sforza family. As a symbol, the ermine was admired as an animal that would viciously fight to the death rather than retreat. The ermine, known for its jittery, quick reflexes and razor sharp teeth, kills its adversaries with lethal, vicious, ripping attacks to the jugular vein in the neck. Such an animal could never be comforted as this one is, stroked by the unwary young lady.

Ten years after completing *Lady with an Ermine*, forty-three-year-old Leonardo began the only fresco still surviving, the *Last Supper*. This masterpiece occupies one end of the refectory of the monastery of Santa Maria delle Grazie in Milan. Begun in 1495 at the request of Ludovico Sforza and completed two years later, this thirty-by-fourteen-foot work depicts one of the most significant biblical events.

In his fresco of this supper celebrating the Jewish event of Passover, Leonardo captured two significant events that occurred at

Leonardo's Lady with an Ermine *shows the contrast in an unsuspecting young woman stroking an ermine, a vicious animal that fights to the death by tearing the jugular vein.*

the gathering: the first communion, called the Eucharist, and Christ's unexpected revelation that one of his apostles would soon betray him.

Leonardo's first task was to prepare the wall before the application of paint, which turned out to be a disastrous mistake. This bit of technical work required coating the wall with a waterproofing stucco compound to protect the painting from moisture seeping through and to provide a medium for bonding the paint. The walls of this convent had not been properly constructed to repel moisture and leached destructive salts and acids. Historian Giorgio Vasari observed in 1556 that the fresco had already begun to disintegrate, leaving the work blotchy. Although in sad condition, visitors can still understand and appreciate the composition.

Leonardo draws attention to the central character of the work in several ways. Seated dead center at the table, which itself is centered on the wall, is Christ. The only calm figure in the painting, downcast eyes and arms spread wide, Christ gestures with one hand to a cup of wine and with the other to a piece of bread, representing the Eucharist. Just as Leonardo positioned the central characters in the *Adoration of the Magi* in a triangle, so too we see Christ assume a triangular form with his downward outstretched arms.

Second to Christ in importance is Judas, who would later betray him. Of the dozens of renderings of the *Last Supper* by various painters, Judas is always isolated from the others by some convention. Most artists have portrayed him physically apart from the rest of the apostles or departing the supper table. Part of the genius of Leonardo's interpretation of the event is to leave Judas at the table in the midst of his companions. To stigmatize him as the betrayer, Leonardo uses chiaroscuro to paint him darker than the others as he recoils from Christ's prophecy, "One of you will betray me."[24]

Famed for his ability to reveal the souls of people in their gestures and poses, Leonardo artfully depicts the individual reactions of the apostles as they protest Christ's pronouncement. Years of detailed sketching of hands bears fruit in the *Last Supper*. The hands of each apostle convey a slightly different reaction to his pronouncement. The third apostle from the left has both hands up as if deflecting the accusation. Immediately to the right of Christ from the viewer's perspective, a hand reaches out to touch his shoulder in a gesture to calm him as another apostle points upward as though asking him to reconsider his statement. On the far right, hand gestures tell the story of disbelief. The supine

The Last Supper *reveals the souls of people through their gestures and poses. Leonardo depicted each apostle by their individual reactions as they protest Christ's pronouncement that one of them would betray him.*

hands of Christ, in concert with his downcast eyes, convey the only sense of serenity, candor, and resignation amongst the group.

The *Last Supper,* considered by many to be Leonardo's most dramatic painting, remains in terrible condition today. Largely lost to the disintegration of the paint, a problem that began almost as soon as it was completed, it also suffered the humiliation of having a doorway cut through the lower center section. This bit of ignominy occurred during the seventeenth century, when the monks, needing a doorway to the adjoining room, failed to see how the doorway could detract from an already badly decomposed painting. Toward the end of World War II, the *Last Supper* also sustained minor damage when bombs struck the refectory.

Return to Florence

In 1499, when Leonardo was forty-seven years old, the French invaded and captured Milan, forcing him to flee back home to Florence. Upon his return he found work painting for the Servite monks, who paid him to paint the interior of their monastery and gave him living quarters. As always, the money Leonardo sought continued to escape him.

Another patron, the city council of Florence, paid Leonardo to decorate the walls of their chambers. The major work he executed, a fresco titled the *Battle of Anghiari,* sadly deteriorated within sixty years of its completion, and no trace of it exists today. While working on this ill-fated fresco, Leonardo began work on his most enduring life's work, the *Mona Lisa.*

The *Mona Lisa* is not only Leonardo's best-known painting, it is also the most identifiable painting in the world and the most

copied. Many visitors to the Louvre Museum in Paris wait for hours to glimpse her inscrutable smile while others, believing the *Mona Lisa* to be overrated, pass quickly by on their way to enjoy other masterpieces.

The *Mona Lisa* was undertaken in 1503 and completed after three years. At the time, Leonardo was a middle-aged man with well-refined techniques that had already brought him notoriety.

Leonardo used many technical details to create the famous smile of Mona Lisa, which people wait for hours in line at the Louvre Museum to see.

Leonardo brought fame to the *Mona Lisa* by the many technical details he employed to create the smile that for generations has captured the attention of viewers.

A close inspection of her smile is remarkably insightful in understanding the technique Leonardo used to achieve the effect. On the right side of her upper and lower lips, as the viewer sees them, Leonardo applied a slight shadowing; a bit more on the upper lip than the lower one. In the middle of her lower lip he lightened the skin color, but he left the middle of the upper lip shaded. The area immediately below the lower lip is darkly shaded. On the left side, Leonardo lightened both the upper and lower lip, but he immediately returned the corner of her mouth to a darkness that radiates out across her cheek. The slight space between her closed mouth is not simply a dark line but a masterful application of chiaroscuro that fuzzes the space, rendering only the hint of a smile that gives it its enigmatic quality.

Many art critics have spilled much ink interpreting the smile of the *Mona Lisa,* and at times they have misled the public into assuming that the work is greater than it is. The classic example of an excessively poetic interpretation is that of Walter Pater:

> All the thoughts and experiences of the world have etched and molded there . . . the animalism of Greece, the lust of Rome. . . . She is older than the rocks among which she sits; like the vampire she has been dead many times, and learned the secrets of the grave. . . . [She] was the mother of Helen of Troy, and, as St. Anne, the mother of Mary.[25]

At Peace with the French

Immediately after the completion of the *Mona Lisa* in 1506, the French leader who invaded and occupied Milan summoned Leonardo to return and paint for him and for King Louis XII of France. Unlike all of Leonardo's previous patrons in Florence and Milan, the French had money and were willing to spend it on his works.

While working for the French in Milan, Leonardo primarily sketched mechanical devices that he never completed. He provided a few insignificant paintings for Louis XII, all of which are now lost. While enjoying the money and appreciation of the French, Leonardo felt obligated to pay a visit to Rome to provide some work for the pope.

In 1514, when Leonardo was sixty-two, Pope Leo X commissioned him to produce some small works; but as was his character, Leonardo became absorbed with technical matters of the works and never completed them. Aggravated, the pope fired him,

never again offering him another commission. Falling ill after this setback, Leonardo suffered a stroke that sent him to a hospital for a short time, where he recuperated. Following his release, Leonardo executed his only known self-portrait, which now hangs in the National Library in Turin, Italy.

Sketched in an unusual red chalk and using a minimal number of lines, this work has a wispy quality. One gets the impression that this self-portrait, although unique, is simply one more of the hundreds of faces he sketched. Considering how little art historians known about this sketch, Leonardo may have dashed it off in a few minutes while waiting for some other more significant activity to occur. Art historians who have studied this rare self-portrait find it disappointing.

Those who have expressed disappointment in the sketch do so because, of all the Renaissance artists, none placed greater importance in the revealing nature of facial details

Most critics are disappointed with this only known self-portrait. Leonardo's attention to the revealing nature of facial details is not present here.

than did Leonardo. Since he left us with only one self-portrait, these historians reason that he could have provided far more insight into his psyche than the sketch suggests. Many see nothing more than another old man diminished by the ravages of time and suffering, a conclusion presented by the eminent historian Sir Kenneth Clark in Wallace's book *The World of Leonardo:*

> This great furrowed mountain of a face with its noble brow, commanding cavernous eyes, and undulating foothills of beard is like the faces of all great men of the nineteenth century. . . . Time, with its spectacle of human suffering, has reduced them all to a common level of vulnerability.[26]

Following his self-portrait, the French king Francis I extended an invitation to Leonardo to move to France. Leonardo packed his belongings, along with the *Mona Lisa* and two other paintings, and departed, never to return to Italy. King Francis was so impressed by Leonardo's abilities and reputation that he required

little more of him than occasional conversations and allowed Leonardo time to pursue whatever interests he wished. Many art historians consider these last years Leonardo's most relaxing and satisfying.

Before the welcoming gestures of the French, Leonardo had found himself despondent, wandering about Italy with nowhere to go and without a patron willing to underwrite his artistic or scientific talents. Leonardo was both exhilarated and saddened by his impending death. His exhilaration stemmed from his deep appreciation to the French for allowing him to pursue whatever projects interested him; his sadness came from his lack of appreciation by his patrons in Milan, Florence, and Rome. Never again to return to Italian soil, Leonardo died on May 2, 1519, in the small French town of Cloux, where King Francis I buried him.

Leonardo was a man blessed with extraordinary powers of observation; and he was capable of painting and drawing these observations with exceptional precision and detail. Although far from his native soil at his time of death, generations of painters following him recognized his innovations in painting and paid him the compliment of copying and improving on them.

Michelangelo the Perfectionist

Artistic genius was abundantly expressed during the Renaissance. For some artists the manifestation was one-dimensional, as is the case of the architecture of Brunelleschi, the sculptures of Donatello, or the paintings of Leonardo. For a very few others, the manifestation was multidimensional. Such was the case of Michelangelo Buonarroti. Initially acquiring his reputation as a prodigious young sculptor in Rome and Florence, popes soon sought his genius to paint the Sistine Chapel, to carve the marble statues of their tombs, and, toward the end of his life, to complete the architecture for the dome perched atop St. Peter's Cathedral.

Cursed by a personality that brought him into personal conflict with many of his patrons and deeply troubled by feelings of inadequacy and inner turmoil, Michelangelo is nonetheless considered by most art historians to have been one of the two most accomplished artists of the Renaissance— Leonardo being the other. Michelangelo's works were very much a product of the artistic forces driving the Renaissance. Unlike Leonardo, however, Michelangelo completed an enormous number of paintings, frescoes, sculptures, and buildings during his ninety years, making him

As the most productive of all the Renaissance masters, Michelangelo completed an incredible number of paintings, sculptures, and buildings.

more productive than any other Renaissance master. Art historian Robert Coughlan pays this unqualified compliment: "Michelangelo was one of the greatest artistic geniuses who ever lived, and, if one were forced to choose one among all others, it is he who would be 'the greatest.'" [27]

A Tough Start

Born March 6, 1475, in the small village of Caprese, Michelangelo was the newest addition to the Buonarroti family that had lived in or around Florence for over 250 years. Acquiring their wealth in trade and banking, family members served on many city councils and contributed to the general well-being of Florence.

Michelangelo's father, Lodovico Buonarroti, unfortunately inherited little of the family money and spent most of his life filling minor administrative posts, preferring poverty to seeking out a better paying job requiring education or skill. Lodovico was a mean-spirited man who focused on his own personal needs rather than those of his family, creating a relationship with Michelangelo that was not a positive character-building experience.

Michelangelo's mother, Francesca di Neri di Miniato del Sera, was a woman of limited ability who bore her husband five sons, Michelangelo being the second. Other than the distinction of being the mother of Michelangelo, nothing more is known of her, except for an early death when Michelangelo was six. Following her death, Lodovico sent Michelangelo to live with a stonecutter until he was ten, rarely visiting him. While living with this family, Michelangelo began to develop his interest in sculpting marble.

Michelangelo ended his apprenticeship with Domenico Ghirlandajo (pictured) after only one year, preferring to work for Lorenzo de' Medici.

Without the influence of his father and mother, Michelangelo failed to focus on school, preferring to wander the art studios of Florence sketching the abundant art he found there. The studios of sculptors especially captured his attention. In 1488, at age thirteen, Michelangelo fearfully told his father of his dream to apprentice himself to one of the many master artists in Florence. As Robert Coughlan poetically observes, "He [Michelangelo] could not read or write, but he learned how to handle a hammer and chisel."[28]

It was at this time in Michelangelo's life that one of his most notorious personality characteristics surfaced. Hearing of his son's wishes, Lodovico raged at Michelangelo for such a foolish plan only to have his son return the rage with equal force, refusing to compromise. Lodovico relented following a vicious confrontation,

allowing Michelangelo to begin his apprenticeship in the studio of the painter Domenico Ghirlandajo. In a contract between Lodovico and Ghirlandajo, the two men stipulated that Michelangelo would remain in the studio for three years, during which time he would receive twenty-four florins in pay.

Early Fame

By the time Michelangelo arrived in Florence, hundreds of Renaissance artists had already made their mark and a few had achieved international acclaim that remains to this day. In 1488 Florence was in the midst of its golden age, and Michelangelo wandered the narrow cobblestone streets and resplendent palazzos admiring the works of Giotto, Donatello, Brunelleschi, and Leonardo, who was still alive and actively working in the city.

Something about the studio of Ghirlandajo conflicted with Michelangelo's sense of reasonableness. He dissolved his contract with Ghirlandajo after only one year, preferring to go to work for the most powerful art patron in Florence, Lorenzo de' Medici. Employing dozens of artists, the Medici family was the greatest patron of the arts in Florence. After Michelangelo had executed a few minor works for the family, Lorenzo died and no further commissions came Michelangelo's way. Learning of the pope's willingness to pay for marble sculptures, twenty-one-year-old Michelangelo went to Rome in 1496 with the assistance of a wealthy, influential Roman named Jacopo Galli.

After two years Galli arranged for an introduction between Michelangelo and a cardinal for a commission to carve a statue. An agreement was eventually struck for Michelangelo to sculpt a marble statue of the Virgin Mary holding her dead son, Jesus, that would later catapult him to such heights that even popes learned to cater to his difficult disposition.

Remarkably mature and skilled for a twenty-four-year-old, Michelangelo carved in marble the magnum opus of his youth, the *Pietà,* meaning "pity," in 1499. This major work, housed in the Vatican, depicts Christ draped across his mother's lap moments after his deposition from the cross. When Michelangelo accepted the commission to sculpt this work five hundred years ago, his patron, Jacopo Galli, made this pledge:

> I Jacopo Galli, pledge my word to his most Reverend Lordship that the said Michelangelo will finish the work within one year, and that it will be the finest work in marble which Rome today can show, and that no master of our days will be able to produce a better.[29]

True to Galli's word, Michelangelo delivered the *Pietà* within one year and carved "the finest work in marble which Rome today can show." Chiseled from a single piece of marble, the attraction of this work focuses on principles of the humanist movement found in the deep passion of Mary's face as she gazes down upon her dead son suspended across her lap.

The *Pietà*'s expression of motherly grief so emotionally moved the pope and the viewing public that many refused to believe that a twenty-four-year-old artist could possess the skills and emotional depth to execute a work of such perfection. Offended by this skepticism, Michelangelo carved his name in Latin on Mary's sash for all to see, "Michel Angelus Bonarotus Florent Faciebat" (Michelangelo Buonarroti of Florence made it). This was the only piece he signed, and no one ever again questioned the authenticity of any of his works.

No one believed that a twenty-four-year-old Michelangelo sculpted the Pietà, *so he signed his name across Mary's sash. This would be the only piece he ever signed and no one ever questioned his work again.*

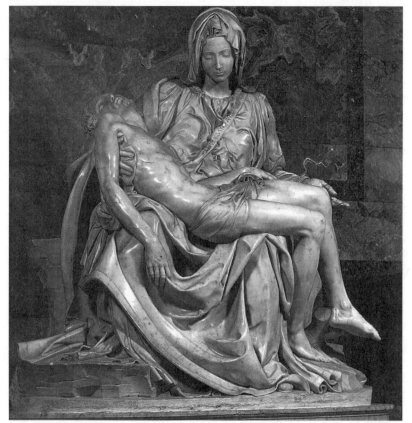

To understand how Michelangelo achieved this moving effect, art historians have identified several sculptural paradoxes that he carved and polished to perfection. At first glance, the viewer does not notice the distorted perspective that Michelangelo has intentionally carved. To prevent Mary from being physically overwhelmed by her larger son, Michelangelo carved a very large Mary so she would not appear dwarfed by Jesus. Art historians studying the *Pietà* estimate that if Mary were to stand, she would be seven feet tall. Michelangelo, when questioned about her larger-than-life size, replied that in matters of art he measures with his eye rather than with a ruler.

Part of the powerful emotional experience of the *Pietà* comes from the wish to deny that the man stretched across Mary's lap is actually dead. Michelangelo assists those who refuse to believe by using artistic techniques, subtly applied, to bring him to life. Chiseling and polishing with unprecedented perfection, the right arm of Jesus hangs with blood-swollen veins, suggesting that life still courses through his body. Michelangelo provides further suggestion of life by portraying muscle tension in his arms, hands, legs and feet, which, although hanging, are nonetheless held in place unlike those of a dead person that limply fall in all directions.

The feature that viewers then and now find both amusing and comforting is Mary's very young, serene-looking face. At the time of Christ's death she would have been at least in her late forties, yet the face Michelangelo chose was that of a young woman in her twenties. When questioned about this apparent inconsistency, Michelangelo whimsically replied, "Don't you know that women who are chaste maintain much fresher than those who are not?"[30]

The completion and unveiling of the *Pietà* catapulted Michelangelo from an untested sculptor to the most celebrated artist of the time. Once scraping to find work to fill time and pay his expenses, Michelangelo would never again find a moment's respite from the agony of his work.

Triumphant Return to Florence

Following the triumph of the *Pietà*, the homesick Michelangelo traveled to Florence to rest. Arriving with great fanfare, he learned of an eighteen-foot-tall battered block of white marble available to a deserving sculptor. Dubbed "the Giant" by the sculptors of Florence who coveted the rare massive block, an art commission in 1501 passed over Leonardo da Vinci and other sculptors to award it to Michelangelo. They authorized the payment of six gold florins a month to complete a statue of the biblical hero

David, famed for his victory over Goliath. Long considered by Florentines to be their patron saint, several respected statues of David already stood in Florence by Michelangelo's predecessors, Donatello and Verrocchio. Michelangelo seized the opportunity to follow in the tradition of these great Florentine sculptors and to surpass them.

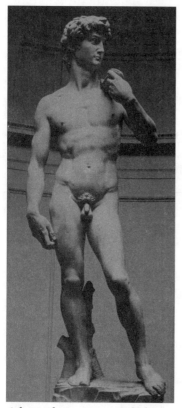

Michelangelo portrayed his *David* very differently than did his predecessors. The biblical tradition of David describes him as a small, timid young man, whose fame came from killing the giant Goliath with a sling. Michelangelo, with this huge stone at his disposal, broke from both biblical and artistic tradition, depicting him more than three times life size in a pose emphasizing superb physical strength and a fixed stare of intractable defiance. Standing with his sling over his shoulder, *David*'s truculent stance and riveting stare epitomize the confidence and courage of a victorious warrior. It is the massive body, combined with his stance and stare, that convey an indomitable will. Michelangelo carved in this masterpiece a heroic figure consistent with the Renaissance spirit of the humanist movement, which lent greater importance to human ability than had been the case during the Middle Ages. The humanist movement, argues biographer Matthew Besdine, greatly influenced Michelangelo's *David*:

After being awarded an eighteen-foot-tall block of white marble, Michelangelo set out to sculpt his interpretation of David as a courageous warrior.

> The young sculptor broke decidedly with the traditional treatment of Donatello and Verrocchio who made little David the agent of God. The insignificant David, who could triumph only through God's miraculous aid, became a giant of a man who could rely on his own power and strength to slay his adversaries.[31]

Well regarded by casual visitors to Florence and by art historians alike, *David* attracts more visitors than any other single work in Florence. With this work, Michelangelo began to develop what would become the hallmark of his unique style, the heavily muscled figures found on later statues and paintings on the Sistine Chapel. The key to understanding Michelangelo's *David* is to understand the influence the Greek sculptors exercised on him as he developed his ideal human form. Michelangelo visited the Roman copy of the Greek sculpture *Laocöon,* located in the Vatican, and borrowed the exaggerated musculature for his *David.*

A Sculptor, Not a Painter

Following Michelangelo's sculpture successes with the *Pietà* in Rome and *David* in Florence, Pope Julius II recognized his genius and commissioned him to paint the ceiling of the Sistine Chapel in 1508. Thirty-three-year-old Michelangelo, famed for his skill as a sculptor, reluctantly accepted the commission, reminding the pope and anyone else who would listen that he was a sculptor, not a painter.

Constructed two years before Michelangelo's birth in 1473, the Sistine Chapel in the Vatican takes its name from its builder, Pope Sixtus IV. Built like a fortress with thick walls, narrow doors, and windows safely placed high off the ground, many contemporaries sarcastically referred to the chapel as "the barn."

For the years between 1508 and 1512, Michelangelo spent most of his days and nights lying on his back painting what many art historians and artists alike refer to as the greatest painting of Western art. Covering the ceiling, which measured 5,074 square feet, was a larger job than Michelangelo initially thought. Paid five hundred ducats for the entire work, Michelangelo continually begged for more to complete the project.

Following the example set by the early Renaissance artist Giotto, who masterfully executed the fresco in the Arena Chapel, Michelangelo set himself to the task of first deciding on the subject of the fresco and then on the organization needed to effectively lay out the extensive work across the entire ceiling. Widely regarded as the pinnacle of Renaissance art, Michelangelo expresses his optimism in humankind on the 43-by-118-foot statement.

Michelangelo divided the ceiling into three large registers, each running the length of the ceiling. Initially planning to paint only the twelve apostles, he later settled on nine great panels for the central register and thirteen secondary panels on each of the two bordering registers. After completing hundreds of preliminary sketches,

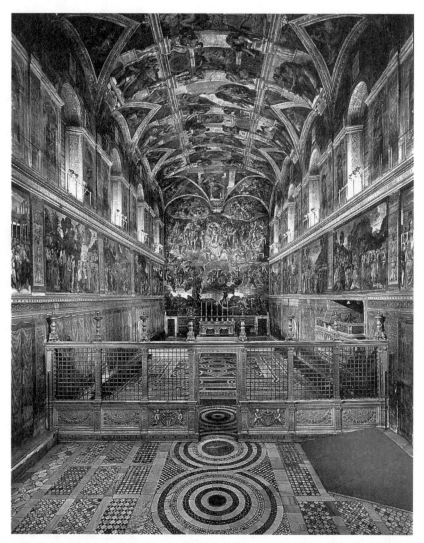

When asked by Pope Julius II to paint the ceiling of the Sistine Chapel, Michelangelo reminded the pope that he was a sculptor, not a painter, but reluctantly took the job.

his final creation totaled over three hundred figures, most of which were from the Bible and a few from Greek and Roman mythology. The two side panels are masterfully painted, but they are secondary to the central register where Michelangelo focused his genius.

The work painting the ceiling was physically the most demanding of any major work Michelangelo executed. For days at a time, without descending the scaffold, Michelangelo lay on his back enduring paint running in his eyes, working by candlelight at night, and sleeping in the sticky mess inches from the ceiling. Working under these

conditions, Michelangelo slept not only in his clothes but in his boots as well. At times he left his boots on so long that, when he finally removed them, his skin came off, leaving him with serious infections.

The enormity of the work created delays and caused conflicts between Pope Julius II and Michelangelo. Visits from the pope to review the progress often ignited violent arguments. The pope became famous for hollering up to Michelangelo, "When will it be done?" followed by Michelangelo's reply back down, "When it is done." Repeatedly running out of money, Michelangelo begged Julius for more and got it. Despite the friction between the two men, each maintained considerable respect for the other.

Large enough to be easily viewed from the floor, each of the nine panels represents a major theme from the Old Testament: the drunkenness of Noah, the flood, the sacrifice of Noah, the expulsion of Adam and Eve from the Garden of Eden, the creation of Eve from Adam's rib, the creation of Adam, the gathering of the waters, the creation of the heavens, and the separation of light from darkness.

The figures of the nine central panels, heavily muscled in the tradition of Greek statuary, are reminiscent of Michelangelo's sculptures. Of the nine panels, many art historians and artists alike consider the *Creation of Adam* to be the quintessential work of the ceiling.

One of the nine central panels in the Sistine Chapel is the Creation of Adam, *considered revolutionary for its depiction of God flying through space.*

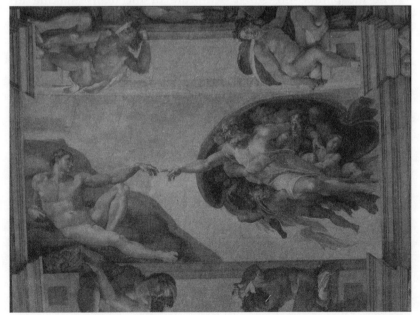

Rarely painted by either medieval or Renaissance artists, and never depicted flying through space, Michelangelo's depiction of God was revolutionary. Charging across the sky with his crimson cloak billowing in the vortex of flight, God has Michelangelo's trademark piercing stare and highly idealized body. Extending his hand to the limp body of Adam, the moment of transmitting life from the creator has all the trappings of the spirit of the Renaissance. This is an optimistic moment, a moment that would have been unthinkable a hundred years earlier, a moment when God and man look similar and act together in harmony.

Over the centuries, the smoke from thousands of candles gradually covered the fresco with a dull coating of soot that sullied the brilliant colors. In the early 1980s the Vatican authorized a team of art restorers to clean the entire ceiling. After twelve years of painstaking restoration, workers have restored the ceiling to its original brilliance.

The Tomb of Julius II

Now sought by all men of wealth and power, Michelangelo was commissioned by Pope Julius II to carve the tomb that he would use at his death. This tomb was to be enormous, requiring many individual sculptures. As was so often the case with Michelangelo, he willingly began the task without realizing the enormity of the project. Michelangelo worked on it intermittently for forty years and never finished it.

The most imposing single sculpture of the many making up Julius's tomb is the *Moses* that Michelangelo carved between 1513 and 1515. The last of his colossal sculptures in the tradition of *David,* it functioned as the centerpiece of the tomb. Moses sits at the base of the tomb holding his tablet on which God wrote the Ten Commandments. A statue of extraordinary power commensurate with *David,* it would be his last of this commanding style.

Moses draws thousands of tourists to the tomb merely to view a bizarre error made by Michelangelo, who rendered Moses with horns radiating from his head. A cruel hoax of fate, the Old Testament Hebrew says that light beams emanated from his head, but the translator erroneously recorded the term for "light beams" as *horns.*

In keeping with Michelangelo's tradition of monumental sculptures, Moses possesses the Greek ideal of physical power combined with spiritual depth, captured in his distant, imperturbable stare. With his fixed, intent gaze, tight lips, furrowed brow, and fingers intertwined with his flowing beard, Moses has the look of a man of extraordinary intellect, deep in thought, and capable of expressing compassion or unleashing terrifying wrath.

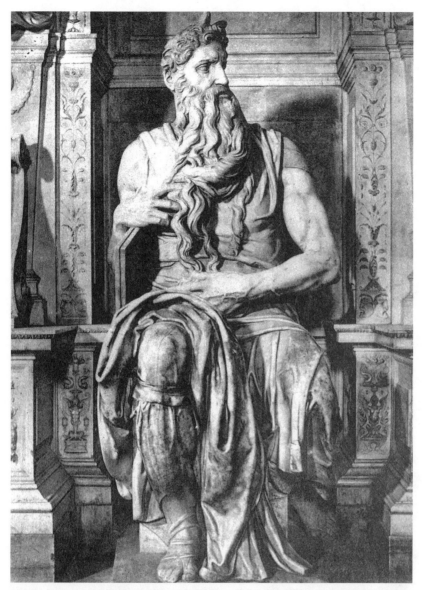

Michelangelo portrayed Moses *with horns protruding from his head, the result of a mistranslation of the term for light beams.*

Fifteen years after completing *Moses*, Michelangelo returned to the tomb of Pope Julius II to hammer out the four *Captives* between 1530 and 1534. Originally intended to decorate the tomb, they stand today in the Vatican, struggling to free themselves from the stones that hold them frozen in time. Often mistakenly regarded by novice art lovers as the early works of an apprentice sculptor, they are the mature works of the great master growing

old. Far from the finely polished serene work of the *Pietà,* the muscular power of *David,* and the inscrutable stare of *Moses,* the *Captives* are the final statement of Michelangelo's view of humankind at the height of his intellectual maturity. They are of interest because they represent a radical break from all of his previous sculptures.

To many art historians, these four statues reflect the inner struggle that Michelangelo endured much of his life. Unlike Michelangelo's earlier works that are detailed, polished, and perfected, the *Captives* are in the grip of a psychodrama. Far from the calm nature of Mary in the *Pietà* and the self-assured stare of *David,* many art critics see in the *Captives* the agony of Michelangelo's troubled life.

A Troubled Spirit

More books have been written about Michelangelo's troubled spirit than any other Renaissance artist. Just as he is known for his peerless artistic abilities, he is also known for his forlorn, secluded lifestyle and his frequent rage.

Preferring to work alone, Michelangelo often sequestered himself behind locked doors and even wooden barriers to keep people away from him. A man of enormous intellect, Michelangelo often saw the contradictions in life that created inner conflict and disillusionment sending him into long periods of depression.

Michelangelo never married, and he seemed to avoid contact with most people, having only a few close friends. His best-known friend was Tommaso Cavalieri, a Roman nobleman whom Michelangelo enjoyed drawing and to whom he wrote many affectionate poems.

Another close friendship was with Vittoria Colonna, whom Michelangelo met when he was painting the *Last Judgment* sometime around 1563. A woman with whom Michelangelo traded poems and other artistic expressions of love, this relationship was the closest Michelangelo came to marriage. Vittoria enjoyed gathering small groups of people on Sunday afternoons for socializing and religious discussions. Her death in 1547 devastated Michelangelo, sending him into despair.

Michelangelo's reputation for criticizing and lashing out at people was a hallmark of his personality. One of the patrons for whom Michelangelo expressed a great deal of respect as well as irritation was Pope Julius II. Their battles over the ceiling of the Sistine Chapel became legendary, often boiling into verbal insults and threats. Julius once struck Michelangelo with his staff, causing

Michelangelo to leave Rome swearing never to return. After their tempers cooled, Michelangelo returned to Rome and apologized for his outburst.

Not known for having lived a happy life, psychiatrists have written widely on Michelangelo's psyche and supposed reasons for his solitude and anger. Giorgio Vasari, a friend of Michelangelo, recognized his isolation but suggested that such was the price he paid for his dedication to art. Modern psychologists have suggested that his loneliness and anger may be the result of his mother's death when he was young, combined with his father's disinterest.

"I Have Not Done Enough"

Twenty-four years after Michelangelo completed the ceiling of the Sistine Chapel, Pope Paul III requested his return to paint the *Last Judgment* on the altar wall of the chapel. During this twenty-four-year hiatus, Michelangelo surprisingly produced no paintings. He began the *Last Judgment* in 1536, when he was sixty, and

Although known for lashing out at people, Michelangelo shared poetry and other artistic expressions with Vittoria Colonna. This was the closest he would ever come to marriage.

finished it four years later. Its location and size, forty-four by forty-eight feet, give it a prominent setting in the Sistine Chapel, although it was of secondary importance to the ceiling.

Conceived when Michelangelo was entering old age, the *Last Judgment* is remarkably pessimistic juxtaposed to the optimism of the painting on the Sistine ceiling, which describes the creation of the world by a loving God. Somber in tone, dark in color, storming with chaos and confusion, a compassionate God is nowhere to be seen in the *Last Judgment*. This great work is very much a psychological profile of an aging Michelangelo.

The central theme of the entire fresco focuses to the viewer's left, where a beardless Christ is partially seated on a throne with Mary. Gesturing forcefully with both arms, he unleashes a cosmic blast that sets the lower half of the fresco in motion. With this gesture, he passes judgment on all the souls who await their fate; his raised arm elevates the chosen to heaven and his lowered arm condemns

the damned to hell. To highlight this central focus, Michelangelo painted the yellow backdrop of light to exaggerate the drama. Crowded around Christ and Mary hover the luminaries of the Bible; the twelve apostles, the patriarchs, the saints, and the martyrs.

Below Christ, and regarded by many art historians as the most interesting part of the work, Michelangelo depicts the souls over whom Christ is passing judgment. In this mass to the viewer's left are the chosen few ascending to heaven while to the right are those awaiting an eternity in hell. Next to Christ's right leg Michelangelo painted the remains of St. Bartholomew, who was skinned alive. Art historians are of universal agreement that the face Michelangelo used for this tortured man, identifiable by a flattened nose, was none other than his own.

Unlike the creation of the world by a loving God on the ceiling of the Sistine Chapel, the Last Judgment *shows chaos and confusion as Christ passes judgment on all the souls who await their fate.*

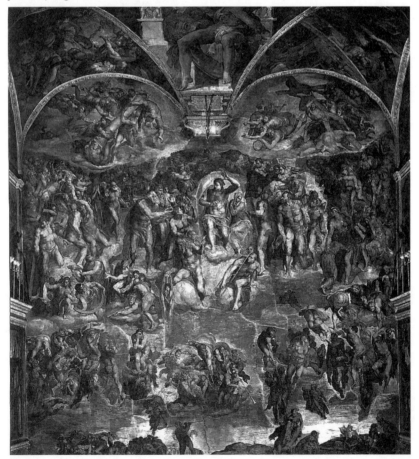

The lowest section, the macabre scene from the underworld, shows dead souls emerging from their graves. They are either being carried aloft to heaven by angels or being ferried across the river Styx by the Roman boatman of death, Charon, who beats their backs with an oar. In both cases, the presentation is unsettling. One would think that Michelangelo would have depicted the souls ascending to heaven with expressions of elation, but he does not. In spite of their good fortune, the lack of exuberance is strangely missing as they scramble upward in darkness and confusion. For the damned, the vision Michelangelo paints is horrific. Gruesome beasts reach up to snatch and drag unsuspecting souls down to the dark depths. Bodies of the damned topple over each other as skeletons scuttle about the floor of hell. Michelangelo painted Biagio da Cesena, an acquaintance of his, as a horned beast in the lowest level of hell in the coiled grip of a snake because he criticized the nudity in the fresco.

What caused Michelangelo to paint such a depressing work so significantly different from the optimistic work he painted twenty-four years earlier on the Sistine ceiling? No one knows, but many art historians and psychiatrists have their theories. Some think the changed point of view was a result of age and a growing awareness of his approaching death; others believe that it was a reflection of his own self-doubt that had plagued him all of his life. His writings tell a sad story of a man who failed to find the appreciation and love from the God he so desperately sought to please. This despair echoes through his later works and thoughts: "I regret that I have not done enough for the salvation of my soul and that I am dying just as I am beginning to learn the alphabet of my profession." [32]

Il Divino Michelangelo

At age seventy-five, and in ill health, Michelangelo would paint and sculpt no more. The one last project that would be a part of his life until his death was the commission from Pope Paul III to act as chief architect for completing St. Peter's Cathedral in Rome.

As reluctant to commit himself to architecture as he was to painting, his brilliance with an architect's pencil was nonetheless as astounding as his success with a paintbrush and chisel. He had already established his reputation as an architect by designing the great square on the Capitoline Hill in Rome, called the Campidoglio, the Laurentian Library in Florence, and the Medici Chapel in Florence.

Engrossed in the details of St. Peter's dome and surrounded by a few friends, Michelangelo died two days before his ninetieth birthday

Throughout his lifetime, Michelangelo gained the title "The Divine Michelangelo" for his many paintings, sculptures, and buildings.

after suffering from a high fever. The sheer volume of work Michelangelo produced—more paintings, sculptures, and buildings than many of his contemporaries combined—along with his stellar reputation, earned him the title Il Divino Michelangelo, "The Divine Michelangelo."

Fate, as is often the case, has a mystical way of softening a loss with an unexpected gain. Such was the case in 1564, when Michelangelo died in Florence. That same year the greatest writer of the English language, William Shakespeare, was born in England, and not far from Florence, the great astronomer Galileo was greeting his first rays of light in Pisa.

Did Michelangelo ever find a sense of contentment in his later years that calmed his tormented soul? Matthew Besdine believes so: "The feel of the marble, the smell of the dust, the work at night, a candle in his cap, the sparks and sounds of the hammer and chisel were his joy, his relaxation, and therapy." [33]

Raphael the Stylist

No one could possibly have known in late fifteenth-century Florence that one more artist, Raphael, was preparing to stand beside the venerable Leonardo da Vinci and Michelangelo Buonarroti as a member of the triumvirate of the High Renaissance. All three of these consummate artists, recognized by art historians then and now as the three titans of the High Renaissance, lived not only at the same time but also occasionally in the same city, the flower of the Renaissance, Florence. As art historian H. W. Janson observes,

> He [Raphael] is the central painter of the High Renaissance; our conception of the entire style rests more on his work than on any other master's. The genius of Raphael was a unique power of synthesis that enabled him to merge the qualities of Leonardo and Michelangelo, creating an art at once lyric and dramatic, pictorially rich and sculpturally solid.[34]

Known as the last great artist of the High Renaissance, Raphael was the only great master to have an artist as a father.

Raphael would be the last great artist of the High Renaissance. By the late fifteenth century, the signature characteristics of humanism, classicism, and the innovations of techniques like chiaroscuro and sfumato had run out of new ideas and stagnation was becoming evident. Janson believes that "the first signs of disquiet in the High Renaissance appear shortly before 1520, in the works of some young painters in Florence. Here is what amounts to a revolt against the classical balance of High Renaissance art."[35]

Early Tragic Years

Born Raffaello Santi in the Italian city of Urbino, seventy miles southeast of Florence, Raphael was the only great master of the Renaissance fortunate to have an artist as a father. Giovanni Santi,

Raphael's father, was a court painter and poet in Urbino, but like so many other secondary artists, he supplemented his meager income by trading corn and corn oil at the local marketplace. Although not destined to be a great artist, Giovanni's influence over Raphael was considerable.

When Giovanni was forty, he married Magia Ciarla, who came to him with a dowry of 150 florins. Magia gave birth to three children, but only Raphael survived. Born on March 28, 1483, Giovanni named his son after the archangel Raffaello, the protector and patron saint of young children. Tragically for Giovanni and the young Raphael, Magia died in 1491, when Raphael was only eight.

Tragedy was not yet over for the young Raphael. Three years after the death of his mother, his father contracted a fever; after several months of discomfort, he died at the age of fifty-four. Giovanni left half of his estate to Raphael, valued at about 860 florins.

Without a father or mother at age eleven, Raphael lived with a caring uncle who loved him very much. Before Giovanni's death, Raphael had been given the opportunity to learn a great deal about drawing and painting from his father. As his uncle saw this talent emerge, he took Raphael to apprentice with the most well-known artist in Urbino, Timoteo Viti. Viti was known to be a wonderful painter and a kind person to all of his apprentices. In 1495, at the age of twelve, Raphael entered Viti's workshop.

Early Apprenticeship

During Raphael's apprenticeship with Viti, which lasted until 1500, Raphael painted minor pieces that were copies of existing well-known works. Although he did not execute any great early works, he nonetheless was developing a style that would later bring him international fame and great wealth. The hallmark of Raphael's style was his ability to borrow characteristics from other painters and to merge them into his own artistic style. British art historian Julia Cartwright describes Raphael's approach:

> From the first Raphael was never an artist of remarkable originality. He did not break new ground or discard old tradition to make room for types and ideas of his own invention. He was, in point of fact, less of an innovator than Michelangelo or Leonardo, than Giorgione or Mantegna.[36]

By 1500 Raphael had learned all he could from Viti. Wishing to find a more capable teacher, he joined the shop of one of the most famous painters of the time, Perugino (1450–1523).

Raphael traveled to the city of Perugia to study under Perugino. Quickly Raphael began to produce some of the best examples of his early period. Raphael's first independent work in Perugia was the *Crucifixion with Saints* that was originally painted for the Gavari Chapel.

A superb example of his early major paintings, Raphael painted the *Crucifixion with Saints* on a wooden panel in 1503, when he was twenty. This work today hangs in the National Gallery in London. Compared to the early works of Leonardo and Michelangelo, Raphael demonstrates in this painting far more development and maturity of technique than did his two predecessors at the same age. Raphael developed early, but he had far better mentors to learn from than had Leonardo or Michelangelo. Compared to crucifixions painted during the late Middle Ages and early Renaissance, Raphael's *Crucifixion with Saints* appears sophisticated, refined, and highly stylized.

Studying this early work, the viewer sees many of the influences of Leonardo but not many of Michelangelo. At the bottom of the painting, where the cross meets the ground, Raphael uses chiaroscuro, so deftly developed by Leonardo. It is interesting to notice that Raphael applied chiaroscuro to the robe of the saint kneeling on the left, but he curiously chose not to do so to the saint to the right. Another hallmark of Leonardo, the distant background with trees, lakes, and mountains is rendered by Raphael in a wonderfully executed sfumato technique. Even the hand gestures of the two saints in the foreground express the inner feelings so commonly associated with Leonardo's style. What makes this work distinctly Raphael's can be found in the aesthetic style of the painting, some of which borders on the pedantic and the absurd.

Raphael produced this self-portrait, drawn in chalk, at age seventeen.

Before Raphael the aesthetic style of artists was to use the play of light and dark either to create a mood of mysticism or to deflect the viewer's attention to the highlighted focus of the painting. In this early work Raphael employed a stark white highlight technique, which he continued to refine in later works. In this painting

the effect is most pronounced on the robes of the two saints in the foreground. The effect that the light creates borders on a blinding light, especially on the robe of the saint to the viewer's right. The purpose for this innovation appears to be a new sophisticated style rather than a new technique creating greater realism.

Raphael's Crucifixion with Saints *was more mature and sophisticated than earlier renderings of the same scene, probably because Raphael had better mentors than his predecessors.*

The angels that float beside Christ initially appear to be a continuation of the long tradition of angels accompanying Christ and other biblical figures, which dates back to Giotto and even to the Middle Ages. A closer look, however, reveals a style of angels never before seen by Renaissance audiences. These two angels do not simply float in the air, as did their predecessors for hundreds of years; they nimbly tiptoe like ballet dancers on little clouds while catching in goblets the blood that drips from Christ's wounds. These touches, along with the scrolling sashes that flow through the air and the two clouds above the cross, one with the face of the sun and the other with the face of the moon, create a pedantic composition that breaks away from the seriousness of his predecessors. Although Raphael performs masterfully in depicting the sensitive faces of Christ and the saints, there seems to be an aspect of highly stylized superfluous decoration in this work unlike any of the earlier interpretations of this most sacred Christian event.

In addition to the *Crucifixion with Saints,* Raphael painted several portraits of the nobility while living in Perugia. Although he was appreciative of his opportunities to paint in Perugia, his thoughts had already directed him to seek out a more exciting city where he could continue learning from the great masters of the time. Raphael had heard of the electricity in Florence because both Michelangelo and Leonardo were at work there at the same time. In 1504, at age twenty-one, Raphael received a letter of introduction allowing him to travel to Florence to study art and to stay with the mayor of the city.

The Magnetism of Florence

Twenty-one years old and in Florence, Raphael observed the many masters whose workshops flourished during the sixteenth century, and he began to establish himself as a great painter. Biographer Giorgio Vasari records the significance of being in Florence to Raphael: "On his arrival the city pleased him as much as did the works of Leonardo and Michelangelo (which indeed came as a revolution to him) and he made up his mind to stay in Florence for some time." [37]

Of the three great High Renaissance masters, art historians generally consider Raphael the one who borrowed the most from the other two in order to create the last great works of the era. It is fair to say that if Raphael had preceded Leonardo and Michelangelo, he might never have acquired the notoriety he enjoys today. Universally regarded as the least innovative of the three giants of the High Renaissance, Raphael built his reputation on his ability

to borrow their techniques and then raise them to new artistic heights of sophistication and refinement. It has been fancifully suggested that Raphael borrowed heavily from others because of a premonition that he would die young, which he did, at thirty-seven. The modern art historian Vincenzo Labella observed that

> during his stay in Florence, through 1507, Raphael's most impressive quality emerged to dominate him—his ability to absorb lessons and then apply them with his strong originality, so as not to take away anything from his over-powering, inimitable style.[38]

Vasari draws a similar conclusion:

> I must record that it was recognized, after Raphael had been in Florence, that influenced by the many works he saw painted by the great masters he changed and im-proved his style of painting so much that it had nothing to do with his earlier manner; in fact, the two styles seemed to be the work of two different artists, one of whom was more proficient than the other.[39]

Like his predecessor Michelangelo, Raphael completed an enor-mous number of paintings, many of which were large frescoes. Un-like Michelangelo, however, Raphael employed a large number of assistants who not only assisted in preparing his paints, the stucco walls, and outlining the forms but, of greater significance to art his-torians, they also painted many of the subjects in his frescoes.

A study of Raphael's paintings reveals many of the techniques, symbols, and signature characteristics of Leonardo and Michelan-gelo. Of the two, Leonardo's works inspired Raphael the most. Vasari tells us that "he [Raphael] stood dumb before the beauty of his [Leonardo's] figures, and thought him superior to all other masters."[40] In this sense, he was very much a part of the High Re-naissance and the other master artists of this period. Although Raphael borrowed from the giants, he also added to what he had borrowed. Raphael's contributions are found in his style, which included strong color contrasts, the juxtaposition of dark and light, fanciful treatment of biblical scenes, and dividing a fresco or painting into two distinct contrasting halves.

Raphael painted and sketched many works in Florence, but his ultimate object was to study the works of the masters, absorbing as much of their techniques as he could. His stay was a time for en-joying his early manhood with several close friends that he made there. Although there is no evidence that Raphael met Mich-

elangelo or Leonardo in Florence, he did find the time to make friends with several other painters. After four years in Florence, Pope Julius II learned of Raphael's talent and summoned him to Rome to take his place among a growing number of masters who were hard at work building, painting, and sculpting the treasures of the Vatican.

The Center of the Art World

Twenty-five-year-old Raphael was experiencing the center of the art world in Rome. Pope Julius II was spending enormous sums of money to decorate the Vatican with the best art that money could buy. Rome would be Raphael's home for the remainder of his life; unbeknownst to him at the time, it would be only twelve more years.

Raphael (pictured) was known for his ability to borrow the techniques of Leonardo and Michelangelo and raise them to new artistic heights.

When Julius II became pope in 1503, he made the statement that he would not live in the rooms that his hated predecessor, Pope Alexander VI, had defiled. Motivated to change and redecorate many of the Vatican's rooms, Julius II summoned dozens of the Renaissance masters to Rome. Raphael was now one of the chosen, and he would begin with *School of Athens.*

Not merely the magnum opus for Raphael, the *School of Athens* is the masterpiece of the High Renaissance. Acknowledged as the epitome of the spirit of the Renaissance, this work achieves what painters from Giotto through Michelangelo pursued: the optimism and sensitivity of the humanist movement, the geometry and mathematical perfection of perspective, painting techniques expressing the detailed perfected human form in fluid movement, and an expression binding the great classical thinkers of Greece and Rome with those of the Renaissance.

Toward the end of 1510, Raphael completed this fresco in the Stanza della Segnatura, one of the many rooms in the Vatican. Intended to represent the twin virtues of truth and reason, its title, the *School of Athens,* was a later addition. This work, depicting the greatest thinkers of Western civilization, connected the contemporary thinkers of the Renaissance to their ancient predecessors in

Greece and Rome. Littered with the greatest minds of Western thought, Raphael architecturally wrapped the entire work in a great arc with a distant perspective that draws the viewer back through classical art and architecture into infinite space and time.

More than 1.5 million visitors come to this room every summer to stand in awe before this twenty-two-foot-long fresco filled primarily with the great thinkers from the golden age of Greece. Raphael reserves center stage for the two most respected thinkers of classical Greece: Plato and Aristotle. Centered precisely under the background arch, Plato gestures toward the sky, representing his abstract philosophies, while Aristotle gestures toward the ground, representing his more practical writings. To bridge these two thinkers to the sixteenth-century Renaissance thinkers, Raphael painted Plato's head and face in the likeness of Leonardo da Vinci.

In the right foreground, the balding man bending over his compass is the Greek mathematician Euclid, whose face Raphael modeled after a colleague, the Renaissance architect Donato Bramante (1444–1514). In the left foreground, the balding man writing in a book while others crane their necks to see what he is writing is the Greek mathematician Pythagoras. To the right of Pythagoras, sitting on the bottom step and leaning against a block of marble, is

Raphael's School of Athens *depicts the great thinkers of ancient Greece and Rome with the realism and perspective that embody the humanist movement.*

the Greek philosopher Heraclitus. Like the others, he, too, appears lost in thought as he scribbles some notes on a piece of paper. Unlike the others, however, he is a man with unusually large legs and knees, and he is the only person who appears disconnected from the spirited energy of the group. When this work was initially unveiled to the public, viewers recognized this man by the clues that Raphael provided: the block of marble, his large physical stature, and the morose pose as he leans on one arm with a downward cast to his head. This is Michelangelo.

With Leonardo and Michelangelo represented in this pantheon of Greek thinkers, it would be an obvious omission if Raphael, the third member of the High Renaissance triumvirate, were not here. To become a part of this esteemed group, Raphael painted himself in the far right corner, just barely poking his head around the pilaster and looking out at the viewer. He seems to be making the statement that he is satisfied to be a part of this illustrious group, even if only as an observer.

The Age of Riches Under Pope Leo X

With the completion of this work, Raphael's reputation in Rome was established. Pope Julius II, delighted with the *School of Athens,* lavished gifts and compliments on Raphael while directing him to continue painting more of the Vatican's rooms. While Raphael was enjoying his newfound fame, the patron who had given him the opportunity was dying. Julius II died in January 1513, passing on the papacy and art patronage to Pope Leo X.

Although art historians cannot find the contracts issued between Raphael and the popes, it is clear that Raphael was becoming a wealthy man by working in the Vatican. The papacy at this time was the wealthiest institution in Europe. Money flowed into the papal coffers from collection plates and from wealthy businessmen seeking papal favors. Such a businessman was Agostino Chigi, a friend of Pope Leo X. Chigi was able to extend his financial empire with the aid of the pope, and in return, he was happy to fund much of the Vatican art. So wealthy was Chigi that he gave a banquet for Leo X at his villa along the Tiber River in Rome, where the food for each course was served on solid gold plates. As each course was removed to make room for the next one, servants threw the gold plates into the Tiber rather than reuse them.

Raphael's fortunes swelled in this environment. In 1515 he purchased several pieces of property near the Vatican with the intent of building a palace, but in 1517 he paid three thousand ducats for a palace called the Palazzo Caprini. The three thousand ducats

were six times the initial amount Pope Julius II paid Michelangelo for painting the Sistine Chapel. Not satisfied with the Palazzo Caprini, he bought a more opulent palace in 1519, which was more consistent with palaces owned by the business elite or the senior ranks of the Vatican.

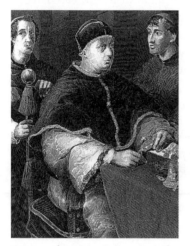

Since the papacy was the wealthiest institution in Europe, Raphael became very rich working for Pope Leo X (pictured) in the Vatican.

The first fresco Raphael completed under Pope Leo X in the Stanza di Eliodoro room was the *Liberation of St. Peter.* The power of this work is derived from the juxtaposition of the stark blackness of night to the brilliant light of the angel. This dramatic and stylistic clash of dark and light made this work an instantaneous masterpiece in 1513. This is a work of extraordinary style and originality never before attempted. Vasari comments on the darkness, which was achieved by the masterful application of chiaroscuro: "As a work reproducing the effect of night this picture is truer than any other, and it is universally regarded as outstanding and inspired."[41] Modern-day art historian Roger Jones cites a 1722 critique of the work, demonstrating its lasting popularity: "[It is] incontestably the finest Night-Piece in the world. . . . Here all is Night, but all shines, with such due subordination however, that One does not hurt Another, or torment the Eye in the least."[42]

At first glance, the unusual three-part segmentation of the work is immediately apparent. To the left, four guards appear to be in a dazed state as one points to the central panel, drawing their attention, and the viewer's, to the focus of the work, the liberation of St. Peter from prison by an angel. In the central panel, Raphael depicts an angel bending over the sleeping St. Peter, bathing him in a brilliant light. The highly stylized, supernatural appearance of the angel has put to sleep the two guards who geometrically frame the angel and St. Peter. The angel bends over to awaken and to assist St. Peter, who sleeps in chains with his hands folded in prayer. To the right, in the third panel, Raphael depicts St. Peter's escape as he is led down the stairs by the angel and past two more dazed guards.

Just as prominent as Raphael's clash of light and dark is his representation of time. In the *Liberation of St. Peter,* Raphael depicts three different events taking place at three different times. Beginning on the left, the first panel depicts the four guards recovering from their drowsy state after being visited by the angel. In the second, central panel, the angel awakens St. Peter in his prison cell. Finally, in the third panel, Raphael completes the triptych with the angel leading St. Peter to safety. Thus, three sequential events occur in one painting.

The success of the *Liberation of St. Peter* gained Raphael even greater notoriety. He was now favorably compared to both Michelangelo and Leonardo. Raphael painted in the Vatican at the same time Michelangelo was painting the Sistine ceiling, and art historians love to speculate whether either master stole a glimpse at his rival's work. No records indicate a friendship between the two, and Michelangelo's difficult personality suggests that he intentionally excluded Raphael from the Sistine Chapel while he completed the work. With the completion of the *Liberation of St. Peter,* Leo X commissioned Raphael to continue with paintings to beautify the Vatican rooms but to paint scenes that would glorify the papacy.

Raphael depicts the Liberation of St. Peter *in three panels (left to right): the four guards, the angel awakening St. Peter, and the angel leading St. Peter to safety.*

At the request of Leo X, Raphael painted Repulse of Attila. *In this fresco, positive symbols represent the pope and the Church and negative, non-Christian symbols represent the enemies of the pope.*

Papal Propaganda

To honor Leo X's request to depict the papacy in a favorable light, Raphael painted the fresco the *Repulse of Attila* in 1514. Raphael cleverly divided the wall into two distinct halves, one glorifying the pope and the other vilifying his enemies. Raphael dramatically creates the confrontation of these two opposite cultures: the papacy on the left, representing all that is good, orderly, and light, and the enemies of the papacy on the right, representing all that is evil, chaotic, and dark. This theme of viewing people and civilizations as belonging to one camp or the other is a theme that originated in the early Renaissance, and one that Raphael dramatically perfected near the end of the High Renaissance.

On the left, Raphael presents positive symbols of the supremacy of the Catholic Church in the form of the pope surrounded by assistants and a figure holding a crucifix. Raphael represents order and calm by portraying the pope and his entourage standing in a composed and relaxed manner. In the heavens, Raphael uses the symbol of light to represent civility and knowledge, while two apostles, St. Peter and St. Paul, hover above the pope in a protective posture, gesturing menacingly with swords towards the figures on the right half of the fresco.

On the right side of the painting, in contrast to left, Raphael presents negative symbols of non-Christian cultures in the form of Attila the Hun (406–453) surrounded by soldiers and other chaotic, dark symbols. As the title of this work indicates, Raphael has chosen Attila the Hun as the antagonist of the pope. Attila, sometimes called "the Scourge of God," was a nomadic warrior who, along with his army, swept across Asia and into eastern Europe, murdering and pillaging as they advanced. On this side, Raphael presents a distinctly dark tone to the figures who chaotically swirl in a maelstrom of soldiers and horses.

As was so often the case with Raphael, he borrowed symbols and forms from his two contemporaries. The rearing horse in the right foreground has the same characteristics as the dozens of horses sketched by Leonardo. The rider of the horse and the soldier in the center have the exaggerated muscular development commonly found in the frescoes of Michelangelo.

A Life Too Short

Demands on Raphael's talent mounted, forcing him to hire increasingly more assistants. At his peak, he and fifty assistants came to the Vatican each day to keep up with the flood of work. Led by Raphael, the responsibilities of his assistants were wall preparation, paint mixing, background painting, general scenes such as buildings or gardens, and all other matters that did not require the detailed application of paint. This system allowed Raphael to conceive the composition, determine the layout, and to paint the delicate, expressive faces and hands.

As Raphael began work on the *Transfiguration*, he could not have known that it would be his last artistic statement.

Considered by many art historians as his most ambitious oil painting, this large painting on wood, nine feet by thirteen feet, now hangs in the Prado Museum in Madrid. Painting the *Transfiguration* between 1518 and 1520, Raphael barely completed it before he died at the early age of thirty-seven in 1520.

Unlike many of his paintings, this one was painted entirely by Raphael without the help of his assistants. He had received criticism accusing him of depending too heavily on his assistants, whose talents were not up to his own standards. The *Transfiguration*, commissioned by Cardinal Giulio de' Medici, was intended to be used as an altar decoration. As the last work of Raphael, we see in it the most sophisticated and most highly stylized artistic statement of his career as well as of the High Renaissance.

Raphael began the painting by laying out the figures in the *Transfiguration* with mathematical precision that was very much in keeping with his Renaissance predecessors. Raphael uses a dual focus in the painting, straying from his predecessors' traditional single focus. Much of the power of this painting rests with the division of the work into two distinct halves: the brilliantly illuminated upper half of the work juxtaposed to the darkness of the lower half.

Illuminated front and back by a blinding white light, the upper half focuses on Christ transfixed in air and flanked by Moses, holding the tablet containing the Ten Commandments, and Elias, clutching his book of prophecy. Having learned the craft of Leonardo and Michelangelo, Raphael placed these three figures in the form of a triangle, as seen in the *Pietà,* the *Last Supper,* and the *Adoration of the Magi.* At the feet of Christ are three apostles who awaken to witness the transfiguration.

In this upper section, the stylistic flying robes complement Raphael's signature bright blast of light, similar to the technique found in the *Liberation of St. Peter.* Relatively new to this work are the violent contrasts found in the highlighting of the robes of the three disciples. These highly stylized and highly focused uses of light are unique to the last phase of Raphael's development and the end of the High Renaissance.

Below the upper portion, Raphael painted a second, separate scene, which was highly unusual. Apparently unconnected with the transfiguration of Christ, except for those figures pointing toward him, Raphael draws the viewer's attention to a young boy. According to biblical scripture, Christ left the disciples to heal this boy of epilepsy. In this scene, the group of disciples helplessly look to Christ for assistance. Raphael focuses the viewer's attention on the boy by having some figures point and others intently stare at him, the use of the chiaroscuro that gives way to bright light, and the boy's exaggerated gestures and desperate facial expressions.

The last independent scene in the *Transfiguration* occurs on the extreme right edge of the painting, where a distant town in the mountains is bathed in the early morning's first rays of light. Very much in keeping with the technique of sfumato pioneered by Leonardo da Vinci, Raphael created this mountain village bathed in the smoky mist of the sunrise.

On April 6, 1520, Raphael succumbed to a fever while awaiting the pope in the rain. At thirty-seven, the short life of the great master was over. Raphael's corps of assistants completed the *Transfiguration,* placing it at his deathbed. The next day, a large

In his last painting, the Transfiguration, *Raphael uses a dual focus unlike his predecessors. The upper half focuses on Christ transfixed in the air while the bottom half draws the viewer's attention to a young boy, whom the disciples are to heal of epilepsy.*

gathering of friends and admirers carried his body through the streets of Rome to his final resting place in the ancient Pantheon.

In his will, Raphael requested burial in the Pantheon, which is where he remains to this day. He left three hundred ducats to each of his servants, sixteen thousand ducats to relatives, and all of his unfinished works to two of his students.

Requiem for the Renaissance

Art historians consider the death of Raphael in 1520 to coincide with the death of the Renaissance. Elevated to a sophisticated refinement and style beyond which it could evolve no further, the many innovative techniques that characterized the Renaissance had finally run their course. As each generation of artists worked to further perfect and elevate the craft of their predecessors, the last one, led by Leonardo, Michelangelo, and Raphael, pushed it over the edge and into a new art form called mannerism.

What Giotto, Donatello, and Brunelleschi started as a fresh new style that radically broke with the somber art of the Middle Ages eventually evolved into slick, glitzy exaggerations. Many art historians see the beginnings of mannerism in Michelangelo's Sistine Chapel ceiling with its highly stylized, physically powerful human forms that whirl about the vortices of the heavens in flowing beards and billowing, colorful capes. The perspective achieved in the *School of Athens* with the drifting clouds in the seemingly infinite deep blue of space had finally reached the point of mathematical perfection. Art historians also see the seeds of mannerism in Raphael's powerful contrasts of light and dark, which eventually evolved into white flashes of light that captured the viewer's attention but did not enhance the understanding of the work.

The highly decorative art of the High Renaissance moved away from the profoundly moving expressions of values and beliefs. This new art placed greater importance on the craft of the artist rather than on the substance of the composition itself. The urge to perfect what the early masters had begun did not cause the death of the Renaissance, but the push toward excessive stylization surely did.

Stylizing the character of Renaissance art detracted from its initial, modest objectives of spiritual enlightenment and moral direction. As refining the style became more important than discovering new approaches to art, the works of the late High Renaissance be-

The death of Raphael is considered to be the end of the Renaissance as well. Here, Leo X bids his final farewell to Raphael.

came caricatures of many of the techniques and compositions executed by the earlier masters. In this sense, Raphael died abruptly in 1520, but the death of the Renaissance began many years earlier.

Whether the world will see another period like the Renaissance or the golden age of Greece is a matter for the future, which is inherently unknowable. Certainly, men and women will continue to find new frontiers, new problems in need of solutions, and new, exciting ideas worthy of exploration. Like so many phenomena in the sciences and the arts, when and where a large-scale revolution in thinking will erupt cannot be known ahead of time, or even when it is taking place, but rather only after it has occurred.

NOTES

Chapter 1: The Rediscovery

1. Quoted in Charles Avery, *Donatello*. New York: HarperCollins, 1994, p. 21.

Chapter 2: Giotto the Painter

2. H. W. Janson, *History of Art*. New York: Harry N. Abrams, 1963, p. 270.

3. Giorgio Vasari, *Lives of the Artists*, trans. George Bull. Baltimore: Penguin Books, 1967, p. 80.

4. Vasari, *Lives of the Artists*, p. 57.

5. Quoted in Vasari, *Lives of the Artists*, p. 57.

6. Quoted in Sarel Eimerl, *The World of Giotto: c. 1267–1337*. New York: Time-Life Books, 1967, p. 7.

Chapter 3: Donatello the Sculptor

7. Janson, *History of Art*, p. 306.

8. Avery, *Donatello*, p. xv.

9. Avery, *Donatello*, p. 12.

10. Vasari, *Lives of the Artists*, p. 178.

11. G. Gaeta Bertelà, *Donatello*. n.p., n.d., p. 24.

Chapter 4: Brunelleschi the Architect

12. Heinrich Klotz, *Filippo Brunelleschi: His Early Works and the Medieval Tradition*. London: Academy Editions, 1990, p. 77.

13. Antonio di Tuccio Manetti, *The Life of Brunelleschi*, trans. Catherine Enggass. University Park: Pennsylvania State University Press, 1970, p. 34.

14. Vasari, *Lives of the Artists*, p. 133.

15. Janson, *History of Art*, p. 314.

16. Vasari, *Lives of the Artists*, p. 135.

17. Vasari, *Lives of the Artists*, p. 136.

18. Quoted in Vasari, *Lives of the Artists*, p. 147.

19. L. B. Alberti, *Della Pittura*. Florence: G. C. Sansoni, 1950, p. 28.

20. Manetti, *The Life of Brunelleschi*, p. 39.

21. Quoted in Isabelle Hyman, *Brunelleschi in Perspective*. Englewood Cliffs, NJ: Prentice-Hall, 1974, p. 88.

Chapter 5: Leonardo da Vinci the Innovator

22. Quoted in Robert Wallace, *The World of Leonardo, 1452–1519.* New York: Time-Life Books, 1966, p. 58.

23. Quoted in Jack Wasserman, *Leonardo da Vinci.* New York: Harry N. Abrams, 1984, p. 10.

24. Matt. 26:21, Revised English Bible.

25. Quoted in Wallace, *The World of Leonardo,* p. 140.

26. Quoted in Wallace, *The World of Leonardo,* p. 172.

Chapter 6: Michelangelo the Perfectionist

27. Robert Coughlan, *The World of Michelangelo, 1475–1564.* New York: Time-Life Books, 1966, p. 10.

28. Coughlan, *The World of Michelangelo,* p. 13.

29. Quoted in Coughlan, *The World of Michelangelo,* p. 73.

30. Quoted in Ascanio Condivi, *The Life of Michelangelo,* trans. Alice Sedgwick Wohl. Baton Rouge: Louisiana State University Press, 1976, p. 24.

31. Matthew Besdine, *The Unknown Michelangelo.* New York: Adelphi University Press, 1985, p. 42.

32. Quoted in Coughlan, *The World of Michelangelo,* p. 192.

33. Besdine, *The Unknown Michelangelo,* p. 104.

Chapter 7: Raphael the Stylist

34. Janson, *History of Art,* p. 369.

35. Janson, *History of Art,* p. 374.

36. Julia Cartwright, *Raphael.* London: Seeley, 1895, p.17.

37. Vasari, *The Lives of the Artists,* p. 287.

38. Vincenzo Labella, *A Season of Giants: Michelangelo, Leonardo, Raphael, 1492–1508.* Boston: Little, Brown, 1990, p. 201.

39. Vasari, *The Lives of the Artists,* p. 289.

40. Vasari, *The Lives of the Artists,* p. 315.

41. Vasari, *The Lives of the Artists,* p. 301.

42. Quoted in Roger Jones and Nicholas Penny, *Raphael.* New Haven, CT: Yale University Press, 1983, p. 125.

1270
End of the Crusades in the Holy Land and the beginning of the Renaissance.

1306
Giotto paints the frescoes at the Arena Chapel in Padua, displaying early examples of perspective and humanism.

1413
Donatello completes the statue of St. Mark, displaying a new fluidity and emotional expression that brings him fame as the greatest sculptor of the early Renaissance.

1420–1430s
Brunelleschi builds the dome of Santa Maria del Fiore in Florence and derives the mathematics of perspective.

1450
Donatello completes *Gattamelata*, the greatest equestrian statue of the Renaissance.

1482
Early use of chiaroscuro and sfumato by Leonardo da Vinci in the *Adoration of the Magi*, considered the first painting of the High Renaissance.

1492
Columbus discovers the New World.

1497
Leonardo da Vinci completes his greatest fresco, the *Last Supper.*

1499
A young Michelangelo catapults to fame after completing his masterpiece, the *Pietà.*

1504
David completed by Michelangelo in Florence.

1506
Leonardo da Vinci completes the *Mona Lisa.*

1510
Raphael completes his magnum opus, the *School of Athens.*

1512
Michelangelo completes the ceiling of the Sistine Chapel, considered the greatest painting of Western art.

1513
Death of the greatest papal patron of the arts, Julius II.

1520
Death of Raphael and the end of the Renaissance.

G. Gaeta Bertelà, *Donatello.* n.p., n.d. This book is relatively short yet it provides a good selection of Donatello's statues along with photographs to illustrate the important characteristics of his technique.

Emilio Cecchi, *Giotto.* New York: McGraw-Hill, 1960. This book is particularly valuable for its detailed photographs of Giotto's frescoes. The photographs fill the entire page with sixty color and thirty-seven black-and-white prints.

Robert Coughlan, *The World of Michelangelo, 1475–1564.* New York: Time-Life Books, 1966. An excellent work on Michelangelo, this book explores the period before the artist as well as the events surrounding Michelangelo's time. This book provides an excellent selection of pictures in addition to a thorough discussion of Michelangelo's work and life.

Sarel Eimerl, *The World of Giotto: c. 1267–1337.* New York: Time-Life Books, 1967. An excellent work on Giotto, this book explores the period before the artist as well as the events surrounding Giotto's time. This book provides an excellent selection of pictures in addition to a thorough discussion of Giotto's work and life.

H. W. Janson, *History of Art.* New York: Harry N. Abrams, 1963. This large book provides a comprehensive discussion of all art from the prehistoric to the modern. Its strength is in its sweeping coverage and ability to highlight significant works and to compare them to their predecessors and successors.

Richard A. Turner, *Renaissance Florence: The Invention of a New Art.* New York: Harry N. Abrams, 1997. This book is a wonderful work on the history of Florence during the Renaissance. It contains a broad breadth of historical information on the city as well as the artists who lived there.

Giorgio Vasari, *Lives of the Artists.* Trans. George Bull. Baltimore: Penguin Books, 1967. This is the most valuable primary source for the lives of the Renaissance artists. Many scholars have written on Vasari's biographies and all agree that they tend to be excessively complimentary yet contain many valuable observations.

Robert Wallace, *The World of Leonardo, 1452–1519.* New York: Time-Life Books, 1966. An excellent work on Leonardo, this book explores the period before the artist as well as the events surrounding Leonardo's time. This book provides a selection of pictures in addition to a thorough discussion of Leonardo's work and life.

L. B. Alberti, *Della Pittura*. Florence: G. C. Sansoni, 1950. Written during the middle of the Renaissance, this work describes the history of painting and art that includes details on Donatello, Brunelleschi, and Ghiberti. Discussions are both aesthetic as well as technical.

Charles Avery, *Donatello*. New York: HarperCollins, 1994. This excellent comprehensive book provides photographs and academic discussions of Donatello's statues.

Matthew Besdine, *The Unknown Michelangelo*. New York: Adelphi University Press, 1985. A psychiatrist who uses Michelangelo's paintings and writings to analyze his psyche writes this work on Michelangelo. Many of the author's conclusions provide interesting insights into Michelangelo's life and work.

Julia Cartwright, *Raphael*. London: Seeley, 1895. This is an old text but it has academic value. The book divides Raphael's life into pre- and post-Rome and contains many historically interesting letters by Raphael.

Bruce Cole, *The Renaissance Artist at Work*. New York: Harper & Row, 1938. Unusual among Renaissance art books, this one presents the lives of the early Renaissance artists from the standpoint of their society, patrons, and art materials.

Ascanio Condivi, *The Life of Michelangelo*. Trans. Alice Sedgwick Wohl. Baton Rouge: Louisiana State University Press, 1976. This work on Michelangelo provides one of the best biographical essays. Interspersed within the biographical information are excellent academic discussions of his art.

Isabelle Hyman, *Brunelleschi in Perspective*. Englewood Cliffs, NJ: Prentice-Hall, 1974. Hyman presents a series of lectures by differing authors on an assortment of topics revolving around Brunelleschi's architecture and life. In addition to these academic lectures, Hyman includes letters and sonnets by Brunelleschi.

Roger Jones and Nicholas Penny, *Raphael*. New Haven, CT: Yale University Press, 1983. This text provides an excellent balance of personal information about Raphael with discussions about his painting. Several high-quality color plates demonstrate his artistic acumen.

Heinrich Klotz, *Filippo Brunelleschi: His Early Works and the Medieval Tradition*. London: Academy Editions, 1990. This beautiful book is one of the finest on Brunelleschi. Its strength lies in its beautiful full-color photographs.

Vincenzo Labella, *A Season of Giants: Michelangelo, Leonardo, Raphael, 1492–1508*. Boston: Little, Brown, 1990. This wonderful work is a superb overview of these three titans of the High Renaissance. It is beautifully illustrated and punctuated with poetic quotations of the artists.

Antonio di Tuccio Manetti, *The Life of Brunelleschi*. Trans. Catherine Enggass. University Park: Pennsylvania State University Press, 1970. Manetti was a friend and biographer of Brunelleschi. This work provides the most insightful observations on the life and achievements of Brunelleschi.

Linda Murry, *The High Renaissance and Mannerism*. London: Thames & Hudson, 1977. Murry provides wonderful insight into the end of the Renaissance and the subtle differences that eventually gave way to entirely different styles.

Frank D. Praeger and Gustina Scaglia, *Brunelleschi: Studies of His Technologies and Inventions*. Cambridge, MA: MIT, 1970. This work on Brunelleschi is one of the most technically detailed discussions of his building concepts and his drawings.

Walter Uberwasser, *Giotto Frescoes*. New York: Iris Books/Oxford University Press, 1950. This tome on Giotto's frescoes has value principally because of its detailed color photographs that allow for careful study of application and color.

Jack Wasserman, *Leonardo da Vinci*. New York: Harry N. Abrams, 1984. This work provides a large number of da Vinci's works, both major and minor. Each work has a one-page textual description facing a photograph of the work described.

Rudolf Wittkower, *Idea and Image: Studies in the Italian Renaissance*. London: Thames & Hudson, 1978. A good academic work that focuses on the major artistic concepts of the Renaissance. Considerable discussion covers proportion, perspective, and humanism. Many works are described and illustrated.

INDEX

PICTURE CREDITS

ABOUT THE AUTHOR

James Barter received his undergraduate degree in history and classics at the University of California (Berkeley), followed by graduate studies in ancient history and archaeology at the University of Pennsylvania. Mr. Barter has taught European history as well as the Latin and Greek languages.

A Fulbright scholar at the American Academy in Rome, he worked on archaeological sites in and around the city and made frequent visits to Florence and the other leading centers of Renaissance art.

Mr. Barter currently lives in Rancho Santa Fe, California, near San Diego, with his thirteen-year-old daughter, Kalista, who is an aspiring actress and killer soccer player. His older daughter, Tiffany, is a violinist and assistant concertmistress with the Virginia Symphony.

Mr. Barter is well known for his slide presentations at local universities, bookstores, and museums throughout San Diego County.